IMAGES
of America
THE CIVILIAN
CONSERVATION CORPS
IN AND AROUND THE BLACK HILLS

To Bill Heller,
Thank you for your
service in the CCC's.
Peggy Sanders

Camps	Companies	Post office	Location (by US Forest Service)
D-Army-1 (Fechner)	2758	Ft. Meade	west edge of current Ft. Meade
F-1 (Mystic)	760,1790,2753	Mystic	SE ? of SW ?, Section 18, T 1N, R 4E
F-2 (Horse Creek)	791,2752,2761	Hill City	Center of Section 32, T 1N, R 5E
F-3 (Este)	789	Nemo	NE ? of NW ? of Section 3, T 2N, R 5E
F-4 (Pactola)	1789,2748	Pactola	NW ? of NW ? Section. 4, T 1N, R 5E
F-5 (Rochford)	792	Roubaix	NE ? of SW ? Section 20, T 3N, R 4
F-9 (Hill City)	793	Hill City	Near center of Section 14, T 1S, R 4E
F-10 (Rockerville)	1794	Rapid City	Near center of south Sect. 24, T 1S, R 6E
F-11 (Haselrodt)	790,2766	Custer	Just west of center, Sect. 10, T 4S, R 5E
F-12 (Custer/Vestal Springs)	791	Custer	NE corner of NE ? Sect. 12 T 3S, R 3E
F-13 (Mayo)	1792	Custer	SW ? of NW ?, Section 23, T 4S, R 4E
F-14 (Lightning Creek)	1783-V,791	Custer	SW ? of NW ? Section 34, T 3S R 3E
F-15 (Tigerville)	765,2748,793,757	Hill City	middle w. sect. line, Sect. 6, T 1S, R 4E
F-16 (Oreville)	756,766,2751	Hill City	west side of Hwy. 385, near Oreville
F-17 (Calcite)	1784-V	Tilford	midway between Tilford and Piedmont
F-18 (Savoy)	792,756	Savoy	site of present Rod & Gun Campground
F-20 (Park Creek/Galena)	2759-V	Sturgis	center of section 1, T 4N, R 4E
F-23 (Doran)	2766, 757, 762	Custer	5 mi. east of Custer, east side hiway 36
F-24 (Sheridan)	793, 762,	Hill City	site of Sheridan Lake Recreation Area
S-1, SP-1 (Pine Creek)	1793	Keystone	SW ? of NW 1/4Sect. 11, T 28, R 5E
S-2 (Doran)	795	Custer	center of SW ? of Sect. 22, T 35, R 5E
DNP-1, NP-1 (Wind Cave)	2754 (transferred to)	Hot Springs	Wind Cave National Park
NP-2 (Badlands)	2754	Cedar Pass	SE ? Sect. 34. T 1S, R 14E
DSP-1 (Robbers' Roost/Narrows)	2757	Blue Bell	NW ? of SW ? Sect. 6, T 3S, R 6E
DSP-2, SP-4 (Lodge)	2755, 795	Custer	present site of Black Hills Playhouse
DBR-2, BR-2 (Orman Dam or Fruitdale)	2750	Fruitdale	west end of Orman Dam

IMAGES

of America

THE CIVILIAN CONSERVATION CORPS

IN AND AROUND THE BLACK HILLS

Peggy Sanders

ARCADIA

Published by Arcadia Publishing,
an imprint of Tempus Publishing, Inc.
Charleston SC, Chicago, Portsmouth NH,
San Francisco

Printed in Great Britain.

Library of Congress Catalog Card Number: 2004101468

For all general information contact Arcadia Publishing at:
Telephone 843-853-2070
Fax 843-853-0044
E-Mail sales@arcadiapublishing.com
For customer service and orders:
Toll-Free 1-888-313-2665

Visit us on the internet at http://www.arcadiapublishing.com

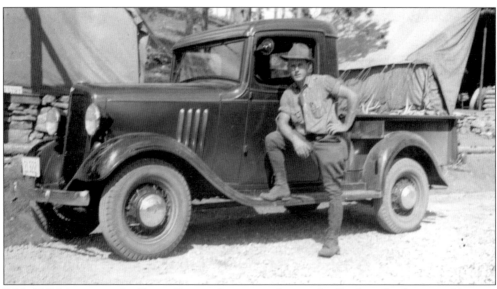

E.H. (Ed) Mason was the Forest Service Superintendent at the Rockerville Camp and later at Summit. On October 15, 1935 he was named superintendent of Camp Custer. Mason donated 364 of his original photos, most with identifying captions, to the U.S. Forest Service District Office at Custer, South Dakota.

On the Cover: The CCC camp at Wind Cave National Park was established on July 16, 1934. This group of men was ready for a typical workday. The four men standing, are, from left to right: Slim Larson, Roy Bledsoe, Park Ranger Tom Sawyer, and Bob Augustine. (Bledsoe photo.)

CONTENTS

ACKNOWLEDGMENTS

The background information came from the Civilian Conservation Corps South Dakota District History for the years 1933, 1934, and 1935. These were all compiled by C.N. Allenger who was in Camp Roubaix, F-6, Company 792 in 1933. To my knowledge histories for 1936 and 1938 through 1942 do not exist. In 1937, the publication was called the Official Annual of the Civilian Conservation Corps, Nebraska–South Dakota District CCC Seventh Corps Area. If readers have rosters or information on the missing history years, please contact me at HC 56 Box, 86, Oral, SD 57766.

It is a privilege to recognize the CCC-affiliated men I've contacted or heard about while researching. I hope to hear from many more. It is to those men still living and those who have passed on, that this book is dedicated.

Duke Allington, Butch Baldwin, Ferdinand (F.J.) Barrie, Herbert Beauvais, the late George Benning, Roy Bledsoe, Arnold Blumhardt, Don Brassfield, Bud Bunch, Everett Coon, Harry Dallas, the late Lyle Derscheid, the late Martin Farrell, Melvin Fernau, C.O. (Civvy) Ford, Russ Frink, the late Francis Haley, Harry Hanson, Melvin Heiermeyer, Palmer Hegge, Sherman Hand, Hans Emil Hansen, Charles Hardin, Harold Hardin, Gordon Hayes, Alfred (Fritz) Heggem, William M. Holden, Ep Howe, the late Bob Humiston, Clarence (Whitey) Juett, Lawrence Karrels, Jack Kirchgesler, William Knodel, Harry Lehman, the late Edward Mason, Pete Modde, Marvin Moore, the late Orlyn Nielson, Harry Nollsch, Charles O'Dell, Jack O'Dell, the late Maurice Osman, John Oyler, Floyd Peck, Gabriel Raba, James Rickard, the late Milt Schleve, the late Stewart Scott, R.W. Sichterman,, Norman Skalland, Elsward Stutzman, Cooley Taylor, Dean Talty, the late A.E. (Tuck) Tucholke, the late Guy Van Nice, Perry Van Wie, Jim Wilder, and the late George Wilson.

In addition these people were most helpful. Amy Ballard, Donna Barck, B. Kay Baumann, Dennis Bucher, the late Betty Coates who encouraged setting up a museum to the CCCs; that museum is a work in progress in Hot Springs, South Dakota at the Fall River County Pioneer Museum. If you have items to donate, you may contact me. Rick Coon, Dorothy Delicate, Margaret Farrell, Samantha Gleisten (my fearless editor), Yvonne Hollenbeck, Irma Klock, Ken Mason, Mary McDill, Dave McKee, Chris Nelson, Bev Pechan, Lenoir Pedersen, Teresa Pedersen, Richard Popp, Dale Sawyer, Ron Schipporeit, Marian Schleve, Kathryn Scott, Juanita Short, Jill Swank, Elda Taylor, Kermit Torve, George and Pat Tomovick, Helen Van Nice, LeRoy Wyatt, Russell Wyatt, and Florence Zimbelman, And as always when I work on a book project, I thank my family for the support.

INTRODUCTION

The Civilian Conservation Corps, established March 31, 1933 by President Franklin Roosevelt was born out of necessity. In 1932 just 25% of men aged 15-24 had even a part-time job. The balance of them and a majority of older men were on the streets, with no jobs to be had. No jobs, no money, no food. Families lined up for free food in soup lines. It was the Great Depression.

Known as the CCC camps, these work camps where unemployed men were housed, fed, clothed, and given medical care—while learning the skills of a trade—accomplished good things for more than just the men who worked for one dollar per day.

Of those $30 dollars per month each man was required to send $25 home for his parents' subsistence. If a man advanced to a leadership position, he got a slight raise. CCC work was arduous; thinning trees, fighting fires, quarrying and crushing rock, building roads and dams—most of it without benefit of tools other than picks and shovels. Many of the men had never held any job before and had to learn what work ethic meant. They also learned that the food was good and plentiful and worth the work.

The CCCs played as hard as they worked. Evenings and weekends were set aside for recreation and education classes. Members went to local dances and in many cases became part of the communities near their camps. The vintage photos in this book take readers back in time to the camps and the escapades of the Civilian Conservation Corps.

Federal agencies already in place were given the task of getting the camps up and running as quickly as possible. The Department of Labor enrolled the men. The War Department (Army) was pressed into service to use its knowledge and experience in handling the needs of transportation, food, clothing, shelter, education, and religious services for such a large number of men. Government agencies in charge of the work projects included the Forest Service, National Park Service, Soil Conservation Service, Bureau of Reclamation, Bureau of Land Management, and state parks.

Nationwide the average CCC enrollee had not graduated from high school, had few if any job skills, and had not yet reached his 20th birthday. Officially they were supposed to be single, although that rule was not always followed. Throughout the CCC years, the age limits for enrollees changed several times. At first it was ages 18 to 25. In 1935, the age range for enrollees was expanded to men between 17 and 28. By 1937 the change became ages 17 to 23. Because of a quota system not all applicants were selected for enrollment. Re-application could be made when the next call for enrollees went out.

There were different types of workers and camps. Soon after the CCCs were in their first work camps it was realized that since the enrollees had no job skills, they needed older, skilled

men as trainers. These men were called Local Experienced Men (LEM) and the age limits did not apply to them. In the Black Hills many of these LEMs were woodsmen. Veteran's camps were separate from the others and they were filled with men who had served in World War I. Those camps had no age or marital status restrictions. Some veterans brought their families along and made their own housing arrangements. There were main camps, such as the ones found on the chart on page 2. Many of those camps had side camps, also called fly or spike camps, under them. Side camps were small groups, generally housed in tents, sent to work on other projects than the main camp. Fly camps made it quicker to get a jump on forest fires, just by the fact that the smaller camps were spread around throughout the forests and they were summer-only camps.

The Army influence was shown mostly in the organization and logistical workings of the CCCs. World War I tents and other equipment came from the Army because it was available in the supply lines. The health screenings, tetanus and typhoid inoculations, and smallpox vaccinations were part of the initial enrollment, as was a conditioning period; all of those were carryovers from the Army. However, in most ways the Army influence was very limited. One of the best examples is in that, although enrollment periods were started every six months, CCC enrollees could usually get out at any time if they had an offer of another job.

Most new enrollees first went to Camp Fechner at Ft. Meade, although not all of them did; some went directly to the assigned camps. In researching this book, I found that as soon as I was "sure" how the system worked, I found exceptions. That contributes to the difficulty of stating unequivocally where men served and even how many camps were in South Dakota. For example, in May of 1933 Camp Fechner operated at Ft. Meade as a detachment. When it became the CCC District headquarters on July 20, 1934 it was designated Camp D-1. District headquarters moved to Fort Crook, Nebraska on February 1, 1936 and from October 15, 1936 until its closure on July 27, 1942, Fechner at Ft. Meade was called Camp SCS-6. The same location had three different designations.

Although this volume is set in South Dakota, the photos are representative of camps and men from all over the nation who served. The CCCs were officially disbanded on July 2, 1942. For further information on the CCC work at Wind Cave, please see another one of my books, *Wind Cave National Park: The First 100 Years*, which contains extensive history and vintage photos.

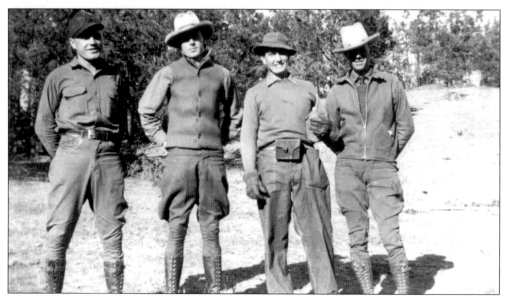

At Victoria, a side camp of Pactola, were (left to right) Palmer Hegge, Shannon, Cecil (Van) Vandal, and Carl Norton, Forestry Supervisor. (Hegge photo.)

One
OVERVIEW OF
CAMP LIFE

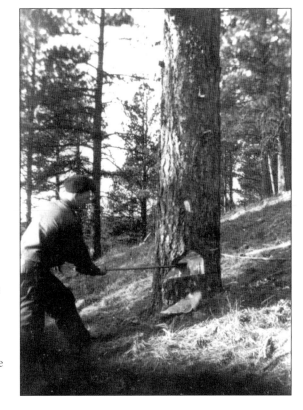

Alfred (Fritz) Heggem grew up on a ranch near Camp Crook, South Dakota and was no stranger to hard work. He joined the CCC in 1934, serving first at Camp Pine Creek, Company 1793 and later Camp Lodge where he helped build the pigtail bridges and the stone building which now houses the Custer State Park Museum and Visitor's Center. Fritz was discharged on March 31, 1938. He lives in Spearfish, South Dakota. (Heggem photo.)

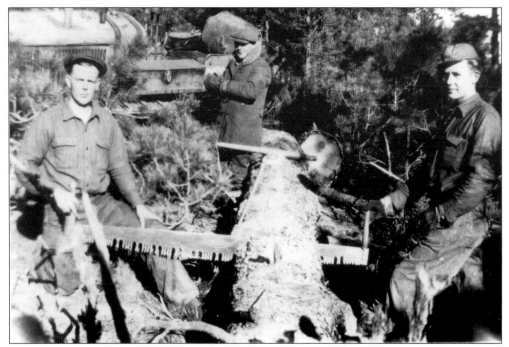

Once a site for a permanent camp was identified, the enrollees often had to clear trees to make room for the buildings. As trees were felled—by hand with an ax—and cut—by hand with a crosscut saw they then were set aside to be made into lumber. Fritz Heggem on the left, an unnamed man who was a catskinner, and Kenneth Simonson from Andover, South Dakota, worked like this often. (Heggem photo.)

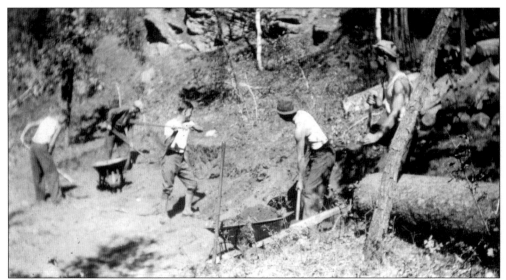

In 1934, these enrollees were clearing a site for Captain Allen's cabin in Lafferty Gulch near Keystone. A typical set of buildings in a camp included a mess hall, kitchen, and storeroom, supply building with cook's quarters, bath house, and laundry, recreation building, latrines, headquarters building, blacksmith shop, a garage, and barracks. In addition to the camp-cut boards, lumber dealers sold vast quantities of lumber to camps under construction. (Van Nice photo.)

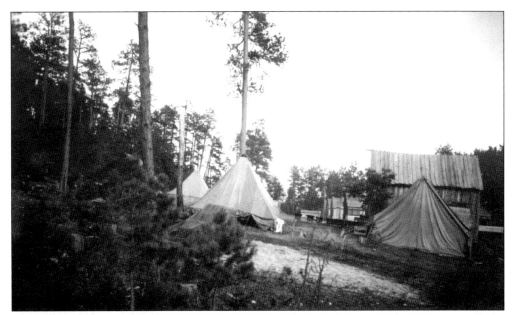

Army pyramid tents, left over from World War I, were used for temporary quarters until the trees were cut, lumber sawed, and buildings constructed. Several times the upper echelons of the corps didn't decide whether or not to make a camp permanent until just before the onset of winter. Once the word came, and cold weather was soon to arrive, entire camps were built inside of one month's time. (Mason photo.)

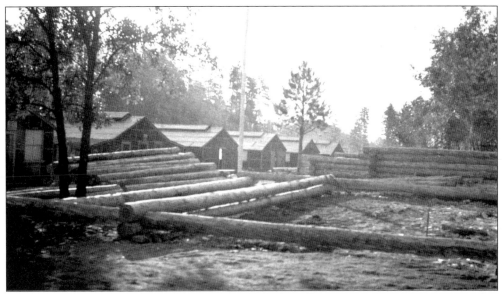

The first tier of logs going up in 1933 at Camp Rockerville F-10, Company 1794 was a cabin for Forest Service personnel. The partially completed log cabin in the background was for Army Officers. Rockerville had four barracks in 1933. F-10 was open from June 16, 1933 until May 25, 1935 when the men moved to Camp F-22 Summit. (Mason photo.)

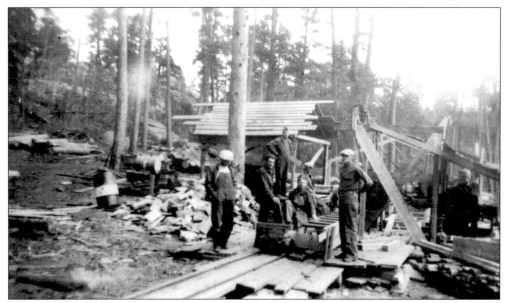

Portable sawmills were used to make the trees into lumber which in turn was used in constructing camp buildings. The Iron Mountain sawmill was in Custer State Park. (Van Nice photo.)

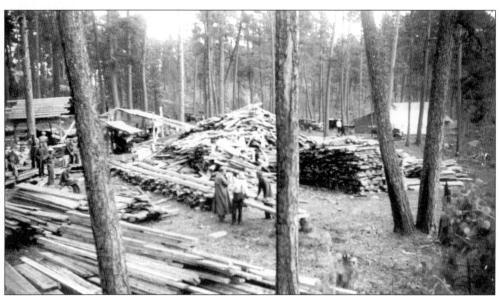

This view of the sawmill shows more of the lumber produced. At the Camp Narrows sawmill all lumber needed, except for the flooring, was fashioned to use in building four new tourist cabins at Blue Bell in 1939. (Van Nice photo.)

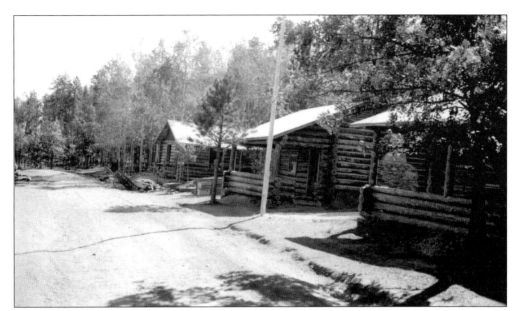

These log cabins were used for facilitating personnel of the Forest Service, the Army, and the hospital. Some of the buildings are still standing on private land in 2004. (Mason photo.)

When the job sites were away from camp, the men were transported in the back of trucks. They left camp at 8:00 a.m. and returned by 4:30 p.m. Some camps operated on two shifts per day and of course this schedule did not apply to them. However they were organized, it was a 40-hour workweek. (Ron Schipporeit photo.)

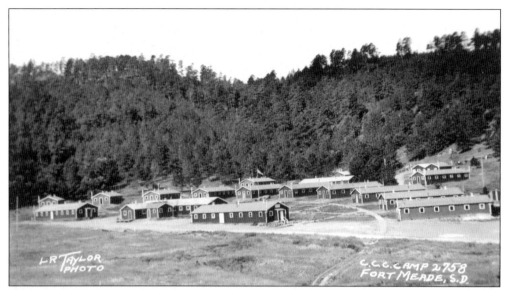

Camp Fechner, D-Army-1, was the headquarters for the CCCs in the Black Hills area. New enrollees commonly were sent to Ft. Meade for their first two weeks. There they had health checkups, vaccinations, and began a conditioning program to prepare them for the physical labor ahead. The ten barracks were built in a semi-circle with the mess hall being the central building. (Sanders photo.)

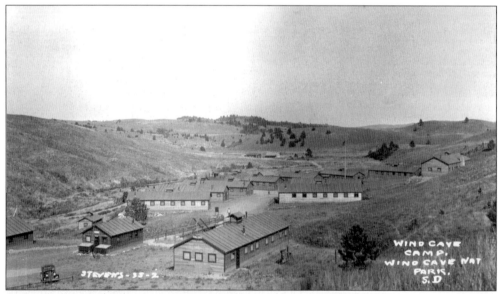

Wind Cave, Camp NP-1, opened July 16, 1934. Projects included excavating—by hand—a 208-foot deep elevator shaft and the construction of an elevator building. Inside the cave, the men worked on a light system and removed and replaced the trail coverings. An extensive photo history on the work done by this camp appears in another of the author's books, *Wind Cave National Park: The First 100 Years*, (Arcadia Publishing, 2003). (Wind Cave National Park photo.)

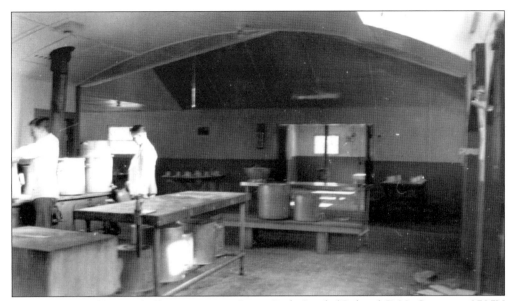

The interior of the mess hall at a veteran's Camp Park Creek (Galena) F-20, Company 2795V where Claire Patterson, now of Keystone, South Dakota, was a cook. Originally Army cooks and stewards prepared the food then CCC men were trained and it was gradually taken over by them, often under the supervision of a local experienced man (LEM.) By 1934 kitchen equipment was updated and included gas burning cook stoves and ovens. (Patterson photo.)

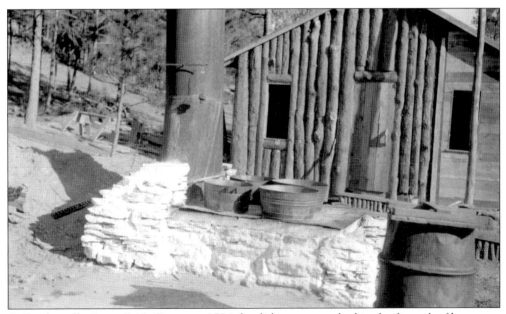

At Rockerville Camp F-10, Company 1794 the dishes were washed in the first tub of hot water then rinsed in the next two tubs, all heated on top of this incinerator. The water tower on the hill simplified getting the water where it was needed. (Mason photo.)

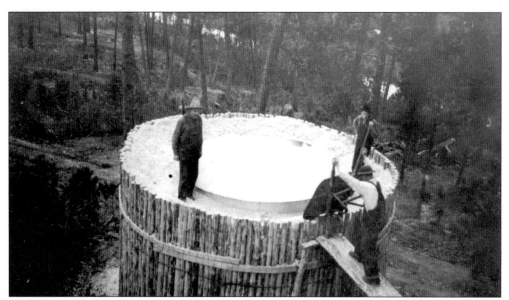

Water for Rockerville was stored in this water tower for gravity flow to the points of use. The dry sawdust was packed around the tank to prevent the water from freezing. (Mason photo.)

In this 1993 photo, First Aid man LeRoy Tichnor of Burke, South Dakota, posed in front of the hospital building at Rockerville. First Aid was a mandatory class for enrollees. (Mason photo.)

In the evenings after supper, enrollees had free time. One of the options they had was to take classes in a vast array of subjects, depending on the availability of instructors and the interest of the students. Common classes were typing and office management, carpentry, auto repair, mechanical drawing, blacksmithing, and welding. Happy (Hap) Lenehan from Wagner, South Dakota took advantage of his study time. (Van Nice photo.)

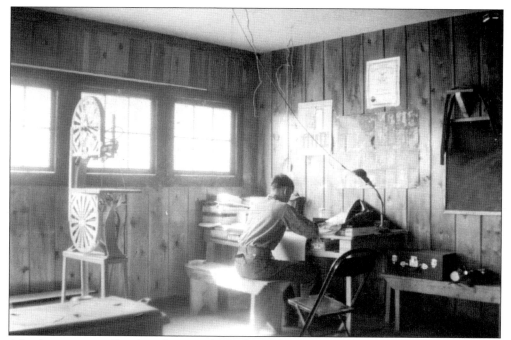

After being an enrollee for a few months, Jack Kirchgesler, now of Rapid City, was named the educational adviser at Camp Custer F-12. His office was spacious and seemed to have all the necessities. Classes were also available on Saturdays. Instruction was hands-on experience for the most part and many of the instructors came from within the camps. (Kirchgesler photo.)

A small wood shop was available to teach wood working skills to enrollees. One small problem stood in the way; none of the equipment worked. Before Jack's students could use it, he had to get each piece into working order. (Kirchgesler photo.)

Although many camps had a large selection of books, each camp had a small library with at least 50 permanent books and an additional 100 books in a camp rotation. Each camp printed its own newspaper which taught typing and journalism skills and kept everyone up to date. The *Windjammer* was published at Wind Cave; others were *Este Ripples*, *Orman Duster*, and Lightning Creek's *Lightning Flashes*. Manual typewriters like this one at Pine Creek Camp, Company 1793 were used. (Van Nice photo.)

18

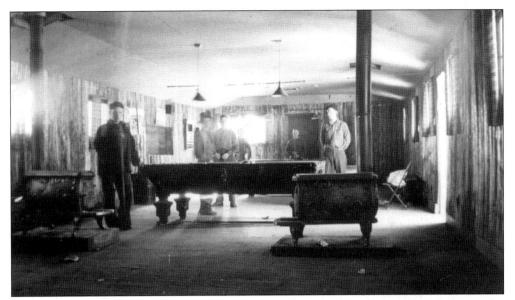

Pool was a favorite activity. (Kirchgesler photo.)

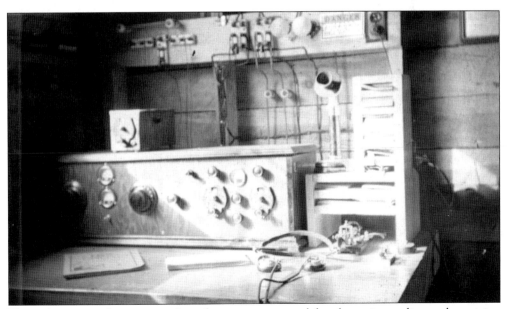

The radio was used to communicate between camps and for classes in sending and receiving radio code. (Van Nice photo.)

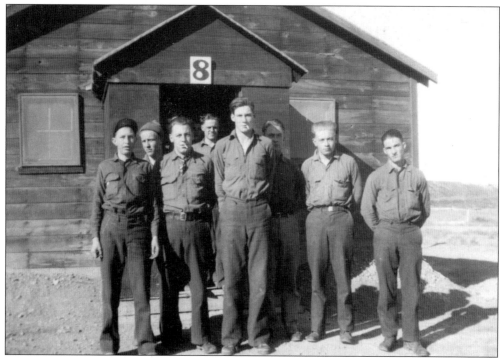

These young men were from many different areas but they formed a cohesive team when on work detail. (Kirchgesler photo.)

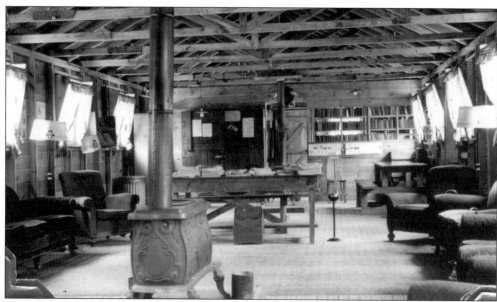

A combined classroom and recreation room at Camp Lodge was spacious and homey. (Heggem photo.)

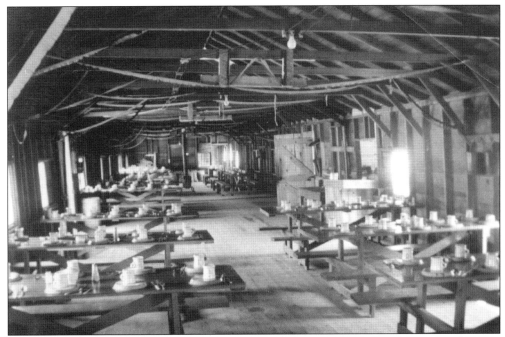

The tables were set for 240 at Camp Este. Mess kits were used in most of 1933, but by 1934 camps had china for daily use. After the meal, the china was washed in hot water, the water evaporated, and the china was replaced on the tables for the next meal. It took care of the problem of where to store the dishes between meals. (Raba photo.)

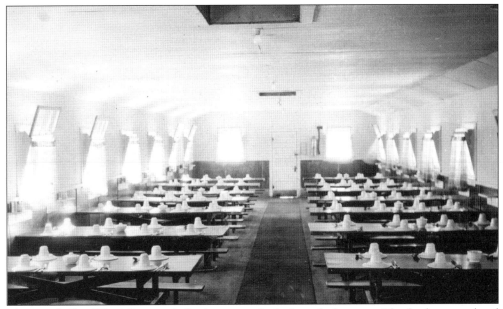

The mess hall at Wind Cave and all other camps looked much the same. The food was good and it was abundant. Even though the men worked at physical labor all day, most of them gained weight in camp and were healthy. Bakers made doughnuts and pies to finish off the meals.

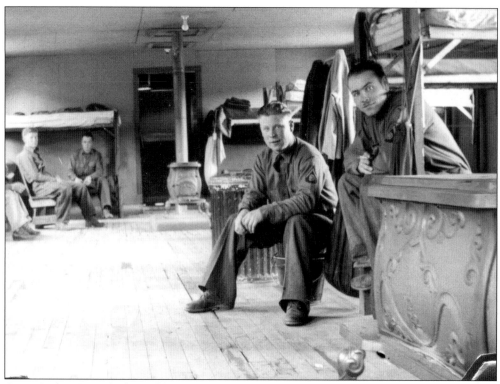

Camp Lodge, SP-4, had metal bunk beds in the barracks. (Heggem photo.)

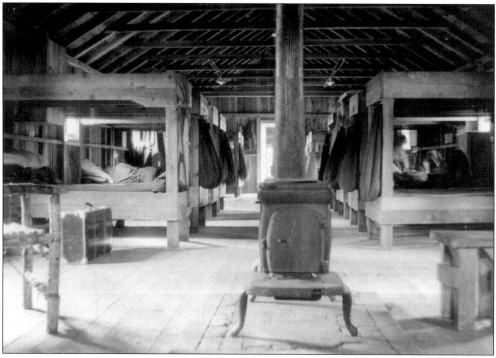

Wooden bunks were in use at Camp Este, F-3. (Raba photo.)

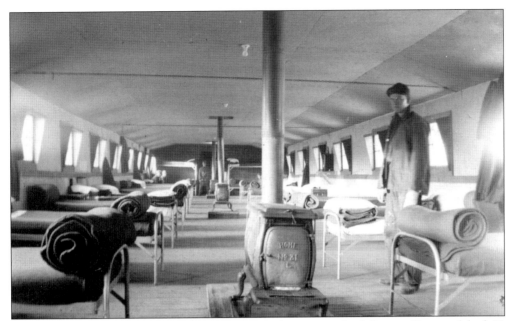

Camp Orman Dam or Fruitdale, BR-2, was on the west end of Orman Dam and had 21 buildings constructed in 84 days. (Kirchgesler photo.)

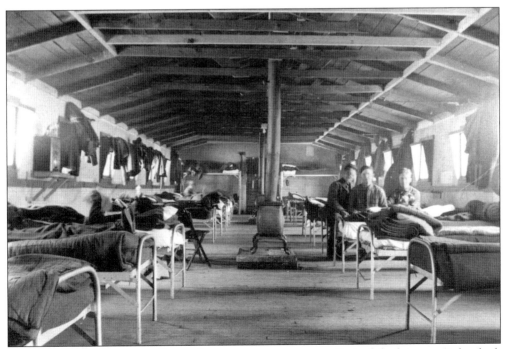

In camps with fewer enrollees where space was not so limited beds weren't bunked. (Kirchgesler photo.)

Certificate of Discharge

from

Civilian Conservation Corps

TO ALL WHOM IT MAY CONCERN:

THIS IS TO CERTIFY THAT * ___STEWART WARREN SCOTT CC7-281106___, A MEMBER OF THE

CIVILIAN CONSERVATION CORPS, WHO WAS ENROLLED ____October 12, 1937____ AT
(Date)

____Ravenna, Nebraska____, IS HEREBY DISCHARGED THEREFROM, BY REASON

OF ** ___HONORABLY. Expiration of enrollment period.___

SAID ___STEWART WARREN SCOTT___ WAS BORN IN ____Anselmo,____,

IN THE STATE OF ____Nebraska____ WHEN ENROLLED HE WAS ____19 11/12____ YEARS

OF AGE AND BY OCCUPATION A ____Farming____ HE HAD ____Blue____ EYES,

____brown____ HAIR, ____Fair____ COMPLEXION, AND WAS____5____ FEET

____9½____ INCHES IN HEIGHT. HIS COLOR WAS ____White____

GIVEN UNDER MY HAND AT ____Camp SP-4,____, THIS ____Eleventh____ DAY

OF ____April____, ONE THOUSAND NINE HUNDRED AND ____Thirty-eight____

____K. W. Foster____
(Name) (Title)

C.C.C. Form No. 2
April 5, 1933

K. W. FOSTER CApt. CA-Res, 537th CA(A

* Insert name, as "John J. Doe".
** Give reason for discharge. 3—10171

** Served:

Camp SCS-10

a. From 10/12/37 to 10/13/37, under War Dept. at Ravenna, Nebraska

Type of work Enrollment & travel *Manner of performance Satisfactory

Camp F-16

b. From 10/14/37 to 12/15/37, under War Dept. at Hill City, S. Dak.

Type of work Forest Conservation Labor *Manner of performance Satisfactory

Camp F-12

c. From 12/16/37 to 4/9/38, under War Dept. at Custer, S. Dak.

Type of work T.S.I. & camp ground work *Manner of performance Satisfactory

Camp SP-4,

d. From 4/9/38 to 4/11/38, under War Dept. at Custer, S. Dak.

Type of work NONE *Manner of performance Satisfactory

e. From _____ to _____, under _____ Dept. at _____

Type of work _____ *Manner of performance _____

F.O., U.S.Army, Omaha, Nebr.

Remarks: Rating Member

MAY 3 1938

AWOL NONE

Paid in full on F/S. Pay $ none

AWOP NONE

Coll. 3.00

Allot. 5.00

Due Co. Fund $2.00 Co. 766 due $1.00

FUTURE ENROLLEES ADDRESS Anselmo, Nebraska

S. C. PAGE CAPT. F.D.

SUP'T. ESTIMATE A SATISFACTORY WORKMAN

F.O.U.S.A.

CHARACTER: Very good

NOT ELIGIBLE FOR A PERIOD OF 6 MONTHS AND SO INFORMED PRIOR TO DISCHARGE

HONORABLE
Discharged: April 11, 1938 at Camp SP-4, Custer, S. Dakota

Transportation furnished from Custer, S. Dak. to Anselmo, Nebraska

(Name) (Title)

* Use words "Excellent", "Satisfactory", or "Unsatisfactory". K. W. FOSTER Capt. CA-Res., 537th CA(AA)
** To be taken from C.C.C. Form No. 1.

U. S. GOVERNMENT PRINTING OFFICE: 1933 3—10171

25

Menu and Roster

Thanksgiving

November 23, 1939

Company 793, C. C. C.
Camp F-24, Sheridan
Hill City, South Dakota

Menu
Thanksgiving
Day

Fruit Salad

Stuffed Olives
Hearts of Celery

Roast Turkey

Cranberry Sauce
Giblet Gravy
Oyster Dressing

Mashed Potatoes
Creamed Peas

Parker House Rolls
Butter

Pumpkin Pie
Mince Meat Pie

Coffee

Cigarettes
Mints
Cigars

COMPANY 793, C.C.C., HILL CITY, SOUTH DAKOTA

COMPANY OFFICERS

Mr. M. G. Ferguson .. Company Commander
Mr. E. M. Heidenreich .. Subaltern
Dr. Halbert H. Hill .. Camp Physician
Mr. C. Henry Overby ... Educational Adviser

TECHNICAL PERSONNEL

Mr. Ben F. Powell .. General Superintendent
Mr. Ralph D. Cypher ... Project Superintendent
Mr. Kenneth H. Eldred .. Technical Foreman
Mr. John Hammond ... Technical Foreman
Mr. Vinton A. Goure ... Construction Foreman
Mr. Malden B. Spencer ... Construction Foreman
Mr. Elmer Cummings ... Construction Foreman
Mr. George Davidson .. Junior Engineer
Mr. Kenneth Luther ... Junior Engineer
Mr. J. William Beranek ... Junior Clerk

EQUIPMENT OPERATORS

John Stockman, Bernard Wilcox, Clifford Olson, William Lorenzen, Ray Fidler,
Earl Gish, Melvin Maudlin, Frank Lindsay, Lyle Crissman, James Moore.

RATED PERSONNEL

Ralph R. Henrickson .. Senior Leader

LEADERS

Geranen, Allman M.	Heberer, Leonard J.	Kucera, Kenneth J.
Hagan, Glenn W.	Hendrickson, Ralph	Stetson, Harry A.
Hanson, Marvin T.	Hilt, Aloysius	Von Colln, Bernard J.

ASSISTANT LEADERS

Beck, William C.
Christensen, Bernard
Conner, Pierre F.
Frey, Wayne H.
Fuhrman, Raymond
Georgeson, Leslie D.

Gisi, Ludwig
Lander, George H.
Mahoney, Richard J.
Mildner, Jeff F.
Pennington, Sherwin D.

Plumb, William R.
Reed, Max W.
Schwichtenberg, Harvey
Webber, Wayne W.
Wyland, Richard R.

MEMBERS

Acers, Eugene D.
Ashley, Harold A.
Barrett, Earl E.
Barnes, Bernard A.
Barrows, Loyd C.
Basham, Walter W.
Beavers, Billie B.
Benson, Robert W.
Berkshire, Wayne W.
Bohle, Raymond F.
Bohr, Delmar F.
Bolan, Marvin N.
Bonner, Gerald W.
Boyd, William J.
Bradley, Russell W.
Bradshaw, Marvin L.
Breen, George M.
Bridenstine, Roy L.
Burns, William J.
Cahoy, Paul
Carney, George E.
Carter, Robert C.
Clarin, Oliver V.
Cook, Charles E.
Cornwell, John J.
Couture, Floyd R.
Cross, Arthur W.
Cross, Lyle E.
Dacar, Lewis M.
Dahlquist, Harry M.
Damberger, Albertus
Davis, Harold
Davis, Loren H.
Davis, Thomas M.
DeGooyer, Gerald
Dempewolf, Paul E.
Dolezal, Frank A.
Dominiack, Mickey
Doren, Kenneth L.
Draggish, Eli J.
Dreher, Francis H.
Drewitz, Oscar J.
Dunsmore, Leeland E.
Duran, Albert
Eberlein, Russell L.
Engel, Ruben
Erickson, Andrew
Fechner, Albert
Fejfar, Clement C.
Fenton, Merritt K.
Ferber, Gordon C.
Fisher, Fonda B.
Fiferlick, Donald
Fristad, Mandus B.
Furrer, Delmer E.
Gahl, Gerald R.
Garner, Walter J.
Giesen, George R.

Gonzales, Bennie
Grambihler, William
Gray, Ira N.
Greiser, Arnold E.
Guthmiller, Earl D.
Hammond, Luther C.
Hanthorn, Jesse
Haskins, Wilmer E.
Hegeland, Merle E.
Helle, Leo J.
Helms, Bruce L.
Henneman, Buhrl A.
Henriksen, Viggo E.
Heth, Willard J.
Hines, William R.
Hjelm, Darwin D.
Hofer, Ernest C.
Hofer, Harold W.
Hofer, Willard W.
Hogan, Matthew J.
Hohn, Everett W.
Hoidahl, Edward J.
Hovland, Oscar F.
Imberi, Benedict
Jacobs, Dale R.
Jacobson, James W.
Jones, LaVerne E.
Juul, Emmett
Kalberg, James L.
Kaster, Robert W.
Keiffer, Leonard H.
Klepke, Elmer J.
Kramer, Robert E.
Krauter, Clifford E.
Krempges, Edward A.
Krutsch, Kenneth W.
Lake, Frank H.
Larsen, Walter R.
Lee, James T.
Lee, Robert E.
Lehman, Myron K.
Lehmen, Robert C.
Lewis, Darwin J.
Lingemann, Leo W.
Linton, Nelson M.
Lokken, Glen V.
Lorenz, Orval M.
Luschen, Lyle G.
McAdam, Howard A.
McBride, Warren A.
McMullen, Clarence R.
McTighe, John R.
Madsen, Arnold A.
Madsen, Earl E.
Marshall, Leland R.
Marvel, Luverne K.
Marlow, Ralph M.
Mathews, Donald W.

Mattson, Carrol W.
Meyer, Russell A.
Miller, Donald H.
Monson, Milton L.
Mraz, Edwin H.
Mueller, Waldo E.
Murtha, Thomas P.
Nedved, Leonard G.
Nelson, Bernard I.
Nelson, Herbert M.
Olson, Vernon L.
Papousek, Robert
Petteys, George R.
Phillips, William A.
Phinney Norman E.
Plambeck, Charles K.
Ravenscroft, Harry D.
Renner, William F.
Rhoades, Eugene R.
Rhodey, Robert F.
Ripley, Lewis B.
Roen, Carl E.
Russell, James E.
Ryan, Parnell F.
Sammons, Lloyd J.
Sass, Maurice I.
Schoenfelder, Casper
Schuman, Eugene A.
Serr, James F.
Skarin, Donald A.
Smikle, Richard C.
Smith, Wood T.
Somervold, Peter W.
Speck, Raymond A.
Stephens, Clifford E.
Stephens, Frank G. Jr.
Stobbs, John A.
Strawn, James R.
Swoboda, Leonard
Sylvis, James C.
Syverts, Franklin
Thin Elk, Theodore M.
Thompson, Clive O.
Tippery, Ralph T.
Urdahl, Burton A.
Valades, Vincente F.
Valentine, Robert T.
Waddington, Lester E.
Wahoahunka, Philip J.
Walters, James J.
Weddell, Clifton E.
Welton, George H.
Winchester, Elwyn H.
Wingenbach, George
Wisner, Richard W.
Woodford, Theodore F.
Wyant, John P.
Yellow Hawk, Collins

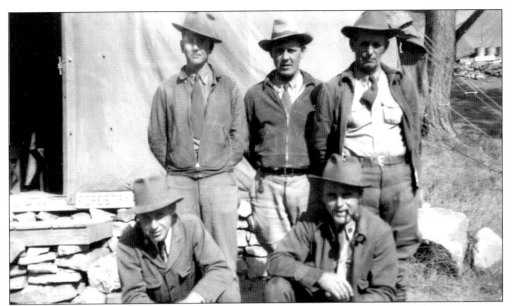

Forest Service personnel assigned to Summit Camp F-22, Company 1794 in 1935 were, front row, left to right: Henry Overby of Hettinger, North Dakota, and E.H. (Edward) Mason of Colorado Springs, Colorado; back row: Neil Hamilton of Ft. Collins, Colorado, Ralph Smith of Keystone, South Dakota, and Elmer Cummings of Hill City, South Dakota. Summit was used by different companies as a summer-only camp from 1934–1937. (Mason photo.)

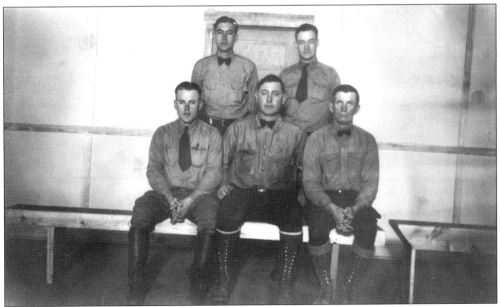

Rockerville Camp F-10, Company 1794's 1933 Forest Service facilitating personnel included front row, left to right: E.H. Mason (who became Camp Superintendent in 1934), Ralph Smith, and Elmer Cummings; back row: Les Shoemaker of Aspen, Colorado, and Camp Superintendent Ranger Raymond McKinley of Keystone, South Dakota.(Koller Studio, Mason collection.)

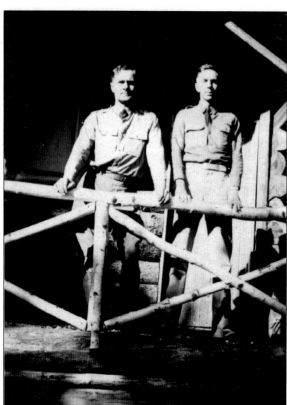

On the porch of the officers' quarters at Rockerville Camp F-10, Company 1794 in July of 1933 were Captain Campbell on the left and Lieutenant May. (Mason photo.)

In November of 1933 these CCC enrollees were overhead personnel. These were enrollees to whom the Army gave leadership positions within the camps and along with that came rankings, such as first cooks, mess steward, or mess sergeant, and supply steward or supply sergeant. (Koller Studio, Mason collection.)

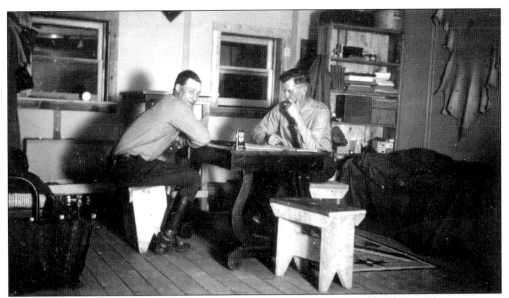

Camp Superintendent Raymond McKinley (left) and Elmer Cummings enjoyed a game of checkers at Rockerville Camp, November of 1933. (Mason photo.)

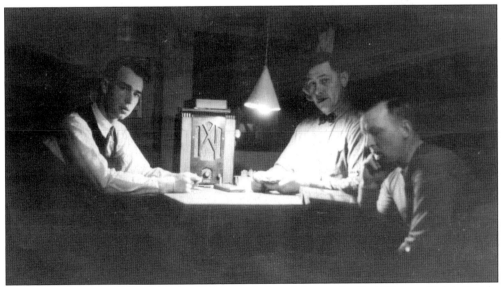

Rockerville Forest Service facilitating personnel, from left to right, Earl Welton, Ralph Smith, and Everitt Clocker played a game of cribbage and listened to the radio. (Mason photo.)

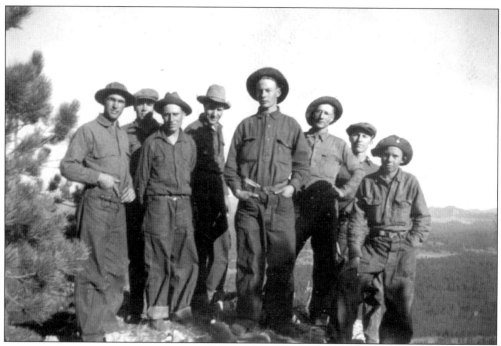

This crew of boys got out into the hills and the limestone when time permitted. The entire outdoors was available for their recreation. (Kirchgesler photo.)

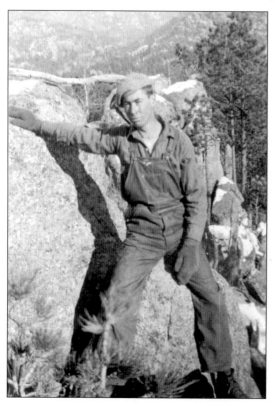

Walter (Walt) Butzke from Dallas, South Dakota was an enrollee at Camp Pine Creek. (Van Nice photo.)

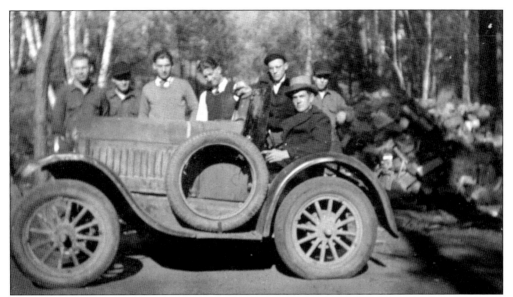

Officially, CCC enrollees were not supposed to have their cars at camp; unofficially, many did and sometime the cars were stored in the trees as though they were camouflaged. Hiram (Hi) Crossen of Newell, South Dakota, had this car in 1934, called Hi's Hootenanny, at Pine Creek. (Van Nice photo.)

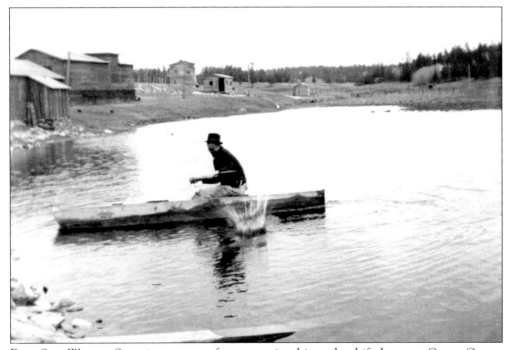

First Sgt. Warren Swearingen went for a row in this make-shift boat at Camp Custer. Outstanding enrollees were rated by the Army officers who controlled and operated the camp, and put into positions of leadership. Even though they were civilians they had rank assigned to them. The one senior leader in the company was called a first sergeant and he was part of the overhead personnel. (Kirchgesler photo.)

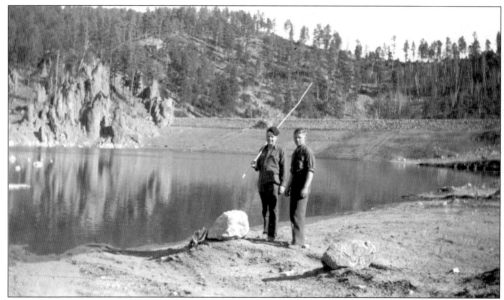

Fritz Heggem and Sullivan enjoyed the fishing in Grace Coolidge Creek which flows on the site of Camp Lodge. A dam and lake, now called Center Lake, were constructed on the creek. (Heggem photo.)

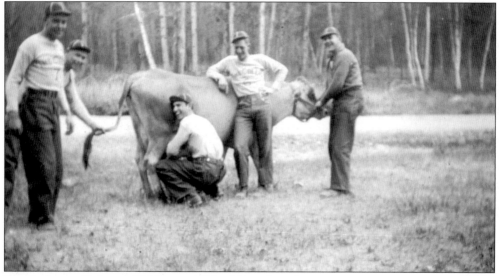

The freshest milk in any CCC camp! (Van Nice photo.)

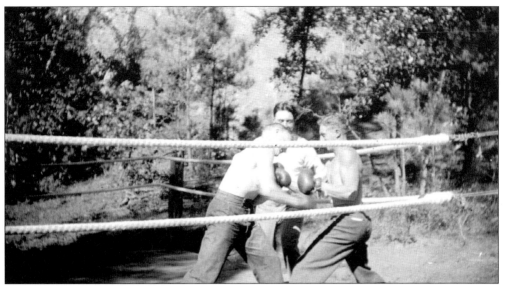

Nile York of Sioux Falls, South Dakota and John Dahn of Scotland, South Dakota went at it in the boxing ring at Pine Creek. Guy Van Nice was the referee. (Van Nice photo.)

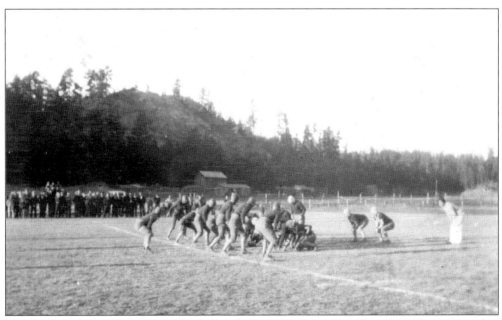

The South Dakota Allstars played football with the CCC Camp Oreville team at Custer. Another sport, kittenball, also called diamond ball, was played more often than baseball because the games were 7 innings long. Kittenball also required less equipment therefore it was cheaper to field a team. Even with a little travel most games could be completed before sunset. In the southern Black Hills, camps were close enough together that leagues were formed. (Van Nice photo.)

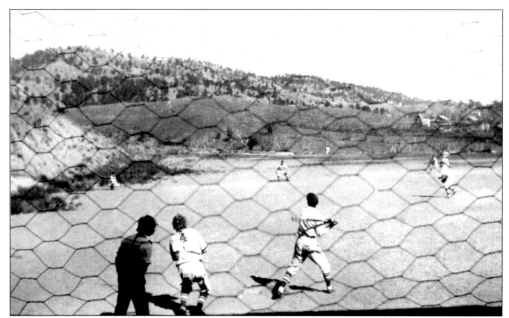

A kittenball had the seams on the outside; it was softer than a baseball allowing players to play without gloves for the most part. Because of its composition a kittenball didn't often travel more than 200 feet, which meant the playing fields could be smaller than for baseball. The diamond ball was inseamed and harder, requiring players to wear gloves. This ball game was played at the Hot Springs Battle Mountain field. (Kirchgesler photo.)

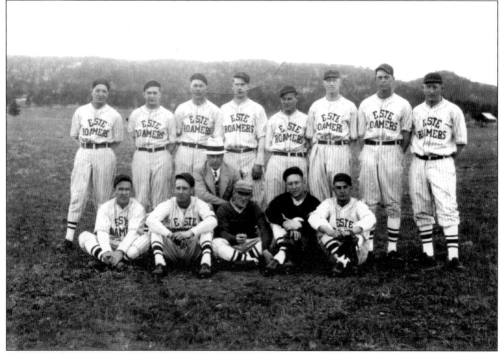

This photo of the Camp Este Roamers was taken at Nemo Camp F-3, Company 789. (Raba photo.)

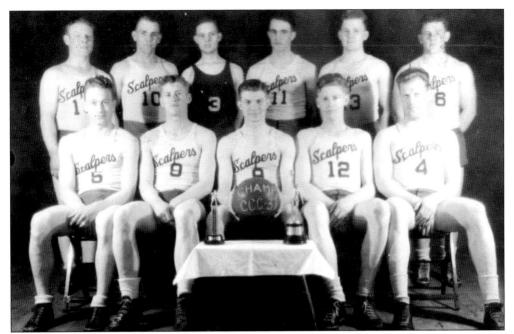

The basketball team of Camp Lodge won the CCC Championship in 1937. For some CCC men, basketball was familiar from their high school days. Even though gyms were needed for games, that problem was solved when independent teams from area towns invited the camps to play. (Heggem photo.)

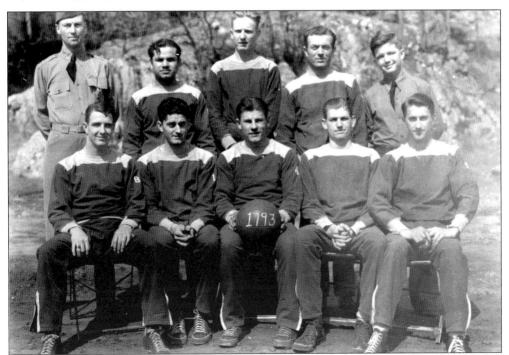

The Lodge team, Company 1793, by now had acquired warm-up suits. Basketball games were sometimes played against local high school teams. (Heggem photo.)

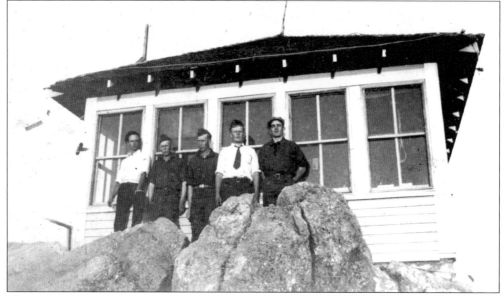

The old wooden lookout at Harney Peak gave these CCC boys from South Dakota a comfortable spot to rest after the climb. Pictured, from left to right, are: Ted McLane of Avon, Al Thompson of Springfield, Don Frederick of Timberlake, Art Lunn of Bonesteel, and Tim Brophy of Fairfax. They were enrollees at Camp Pine Creek, Company 1793 in June of 1933. (Van Nice photo.)

Don Fisk of Sioux Falls, South Dakota was not to be left out of the fun at the old lookout. (Van Nice photo.)

Milo Feleo was a cook supervisor at Camp Black Fox, F-25, in 1941. Information on Black Fox is conflicting. One reference says it was another name for Camp Rochford and a second one says Black Fox was a side camp so details are not listed on the camp chart at the beginning of the book. (Patterson photo.)

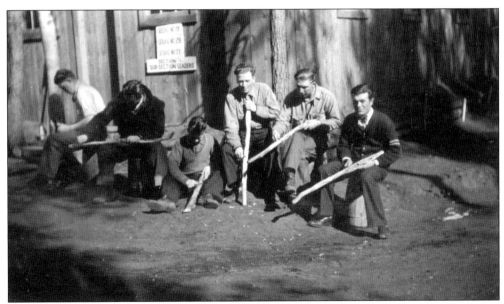

Whittling diamond willow canes was a craze in the Camp Pine Creek. Diamond willow grows along creeks in mountainous areas. Before whittling begins, the bark is removed which exposes the diamond shapes. The shapes are natural, caused by a beetle eating into the stem then a fungus grows in the hole the beetle made. The fungus expands as the willow grows thus creating the diamond design. (Van Nice photo.)

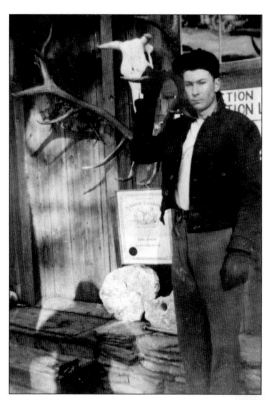

Nobel Witt came from Frederick, South Dakota to Camp Pine Creek and soon was promoted to leader. (Van Nice photo.

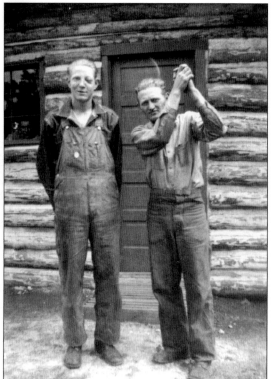

There must have been some victory being celebrated by Robert "Squeaky" Rhodes of Custer, South Dakota, (left) and Hugh E. "Huey" or "Red" Blessing of Ardmore, South Dakota. (Kirchgesler photo.)

40

CCC members from Camp Wind Cave, NP-1 spent time improving roads and paths at the State Soldiers' Home in Hot Springs. The grounds were surveyed by Harry Rolfs, engineer foreman from Wind Cave, and 20 men worked on the job. The road leading from the main gate on Minnekahta Avenue to various buildings on the grounds was prepared for an oil surface. Telephone poles were removed from the interior of the grounds. (Dale Sawyer photo.)

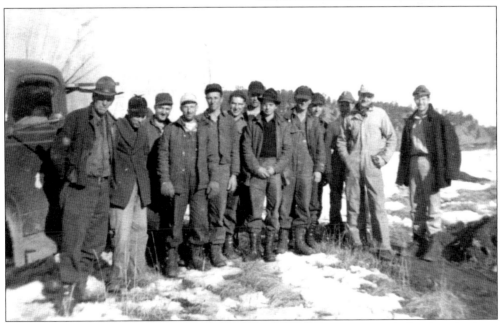

Tom Sawyer, park ranger from Wind Cave, was the supervisor on this work detail at the State Soldiers' Home. The straight walk was eliminated and replaced with a newly constructed walk which followed the contour of the north and south sides of the established lawn. Cedars, elms, and other trees were planted around on each side of the walk. In time the veterans and their ladies and visitors would be able to walk on a shady path. (Dale Sawyer photo.)

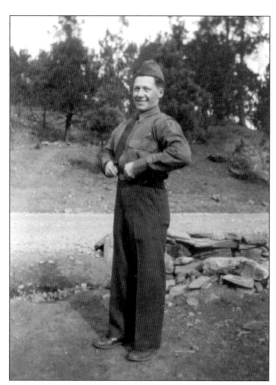

Gabriel Raba, Camp Este, showed off his olive drab winter dress CCC uniform which was issued between 1933 and 1938. Beginning in 1938 a forest green winter dress uniform was introduced along with an olive drab uniform with a new style of blouse. For work the men wore a practical uniform of a blue cotton work shirt and blue denim work pants. (Raba photo.)

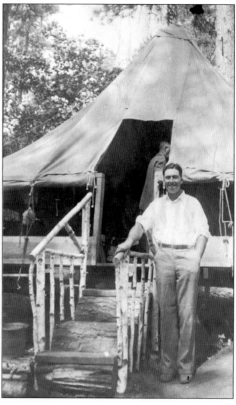

Guy Van Nice enrolled July 15, 1933 and was sent to Pine Creek. He was an outstanding enrollee and was named a leader on August 11, 1933. He held that position continuously until he was appointed foreman on August 28, 1935. Most of his work was in road construction and concrete work. He was also an accomplished photographer. (Van Nice photo.)

Two
MEMORABLE
MOMENTS

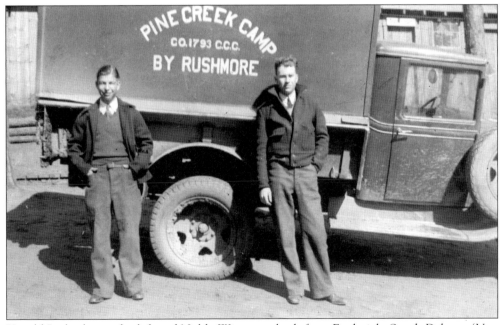

Harold Jankoske on the left and Noble Witt were both from Frederick, South Dakota. (Van Nice photo.)

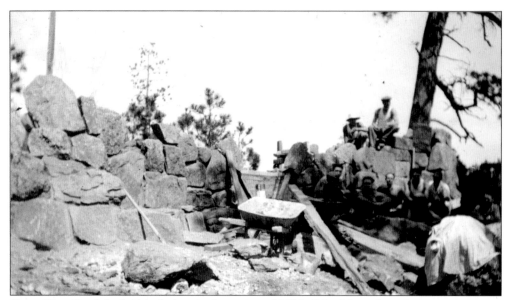

Camp Pine Creek built this shelter in the spring of 1935. (Van Nice photo.)

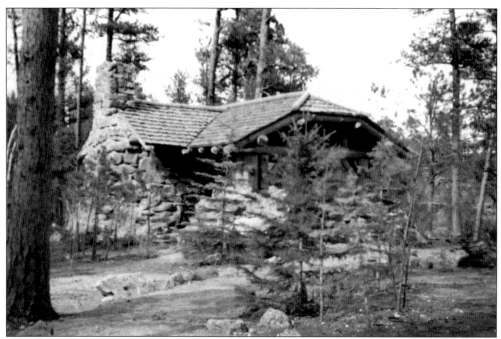

Once the stones were in place and the roof on, this shelter at Pine Creek afforded picnickers a place out of the elements. (Van Nice photo.)

"Captain Mac" was Army Reserve Captain C.T. McEniry, commander at Pine Creek in 1934. He hailed from Des Moines, Iowa. (Van Nice photo.)

Camp Pine Creek was one mile north and one mile west of Mt. Rushmore. The barracks were constructed nearly in a circle. The terrain was uneven and once an area was level enough for construction it was put to good use, with the buildings close together. The camp was located on the west side of the lake. (Van Nice photo.)

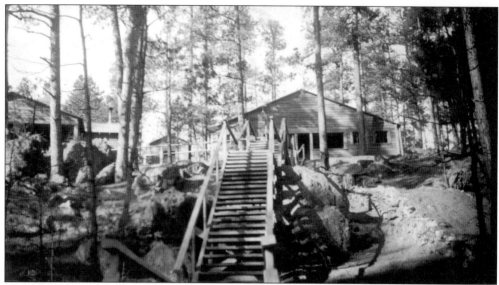

The officer's and foremen's quarters were built about 40 feet higher than the rest of the camp at Camp Pine Creek. (Van Nice photo.)

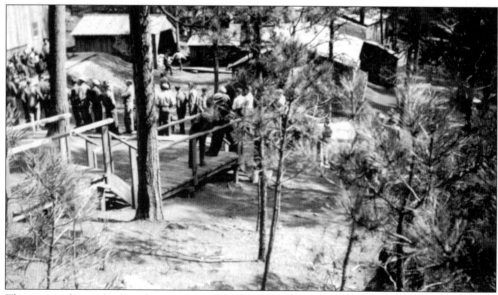

This image shows the line for pay day at Pine Creek. (Van Nice photo.)

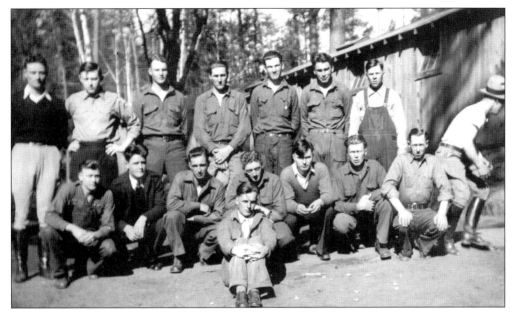

One of the men in this bunch of Camp Pine Creek workers wasn't about to sit still a moment longer. The camp had an average occupancy of 215 men. (Van Nice photo.)

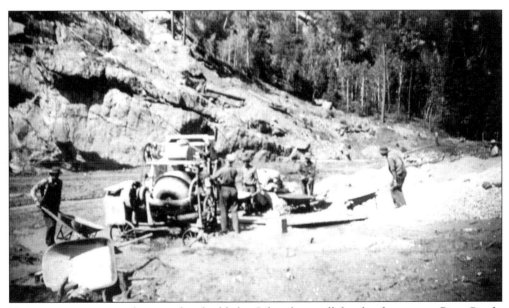

Here, men are seen making mud to build the 5-foot key wall for the dam across Pine Creek. (Van Nice photo.)

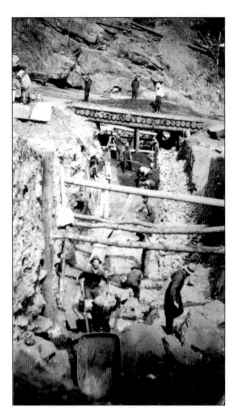

The building of Pine Creek Dam is seen here. Harry H. Hacket from Rapid City was the first superintendent of Camp Pine Creek and the supervisor of building the dam. The state corps of engineers assisted the CCCs in the dam construction. (Van Nice photo.)

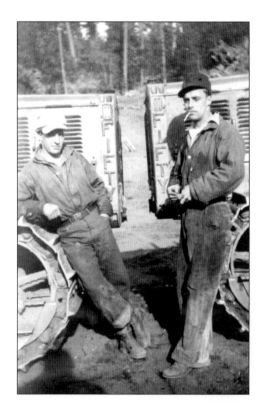

Catskinners at Pine Creek included Lewis Sagmoe of Dell Rapids, South Dakota on the left, and Oscar Manson of Humboldt, South Dakota. (Van Nice photo.)

Forrest "Frosty" Ryan of Harrold, South Dakota is seen here at Pine Creek. (Van Nice photo.)

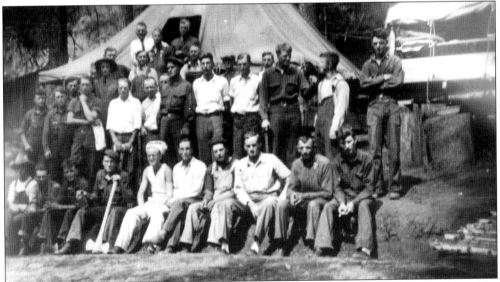

Part of Company 1793 is seen here at Pine Creek. With the nearest telephone service five miles away at Keystone, two amateur radio operators, Denzel Begley and John Van Bockern, both from Lennox, South Dakota, received permission to scavenge radio transmitting equipment from Signal Headquarters at Ft. Meade. Schedules were set up between Ft. Meade and Pine Creek for regular communication checks. Camp Doran, which had an ambulance, joined the group, helping out Pine Creek in emergencies. (Van Nice photo.)

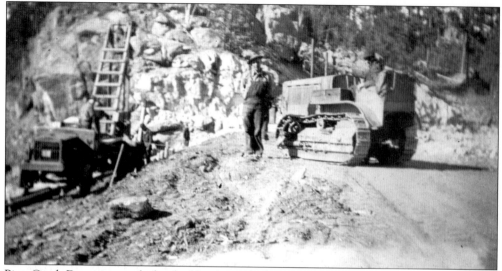

Pine Creek Dam was nearly finished by the end of 1933. (Van Nice photo.)

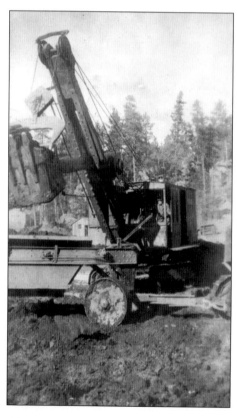

Excavating at the Pine Creek Dam site covered 17.92 acres when completed. (Van Nice photo.)

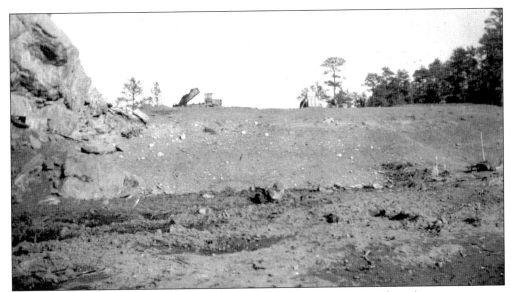

This photo shows dumping a Lynn at Pine Creek in 1934. (Van Nice photo.)

The back of Pine Creek Dam was structurally sound. (Van Nice photo.)

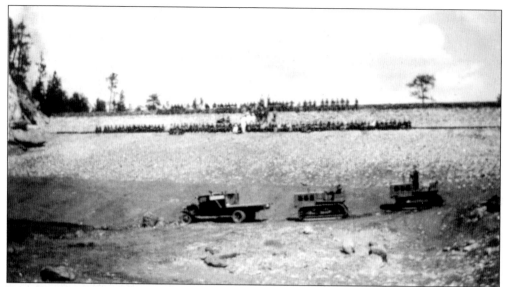

Even though equipment was used, much labor was still done by hand on the dam at Pine Creek (Van Nice photo.)

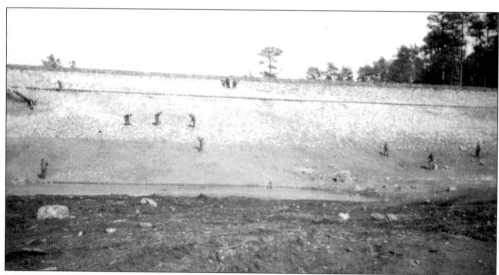

Men with shovels are seen here putting the finishing touches on Pine Creek Dam. (Van Nice photo.)

The CCCs made a foot path around Horsethief Lake as an added recreational choice. The current campground is at an elevation of 5,000 feet and has both tent and RV sites. (Van Nice photo.)

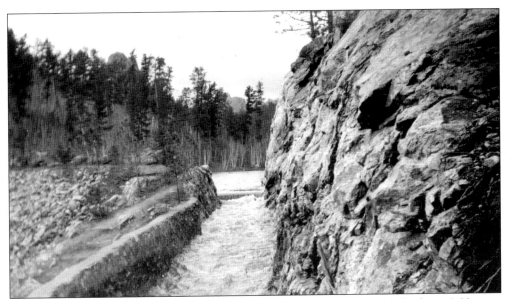

Water started running from the Pine Creek Dam Spillway into Horsethief Lake at 9:32 p.m., May 30, 1935. (Van Nice photo.)

The finished Horsethief Lake is shown from Mt. Rushmore in 1935. This recreation area was congressionally sponsored by South Dakota Senators Norbeck and Bulow. (Van Nice photo.)

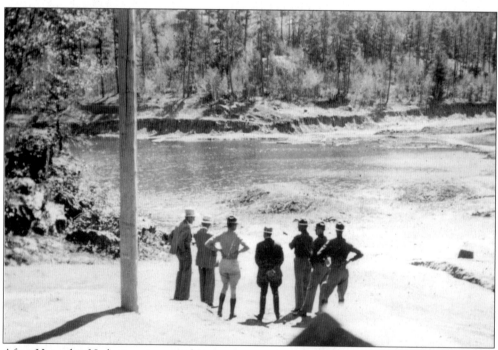

After Horsethief Lake was in use, this group came to see the work and accomplishments of Company 1793. Pictured, from left to right, are: Superintendent of 1793, M.A. Garland; National Director of the CCCs, Mr. Fechner; CO of 1793, Captain McEniry; E.C.W. Inspector, K. Jones; CO of Ft. Meade, South Dakota, Colonel Pope; Regional Forester, Mr. Peck; and Second in command of 1793, Lieutenant Caenan. (Van Nice photo.)

Camp Galena, also called Park Creek, was located about eight miles southwest of Sturgis near the old mining town of Galena, along the west bank of Park Creek. Consolidated Power and Light Company of Deadwood supplied the camp's electricity. (Patterson photo.)

This is one of the prime photo-shoot points at Galena. On the left is Bill Kennedy, Butch Mueler is in the hole, Claire Patterson is the man in the back, and the man on the right is unknown. (Patterson photo.)

Harry Hanson, currently of Gordon, Nebraska, was assigned to Oreville Camp F-16, Company 2751 near Hill City. After working in the Black Hills for a few months, Company 2751 was sent to Camp DSE-224 near the town of Lake Norden in eastern South Dakota. They worked on Lake Poinsett raising shorelines, digging ditches, and erosion control projects from August 4 until October 19, 1934. On October 20, the men boarded the train at Estelline for the return trip to Oreville.

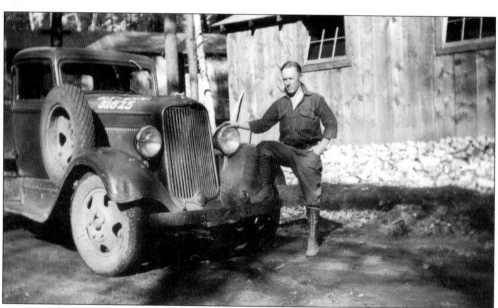

Carl Crandall of Dallas, South Dakota was a truck driver at Camp Pine Creek in 1934–1935. (Van Nice photo.)

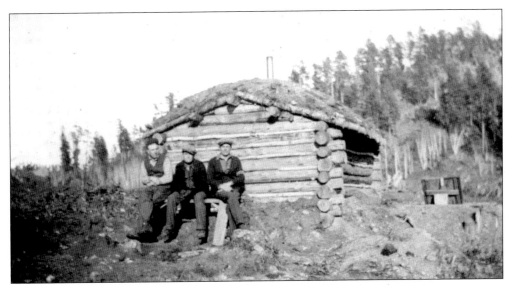

The pump house at Pine Creek offered a restful view. (Van Nice photo.)

Captain R.W. Allen from Fargo, North Dakota was the Army Reserve Medical Officer at Pine Creek in 1934. (Van Nice photo.)

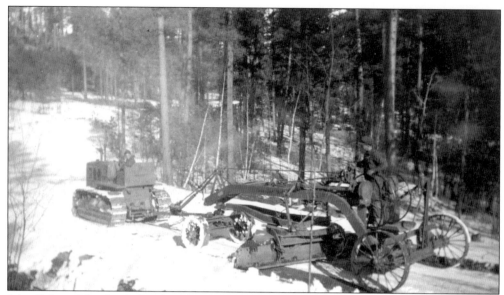

John Dahn of Scotland, South Dakota and Guy Van Nice are seen here blading snow in the area of Camp Pine Creek in 1934. (Van Nice photo)

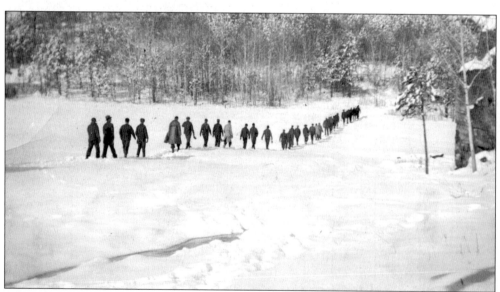

When the job site was close enough the men walked to work in the woods. According to Palmer Hegge, "When we were thinning timber, we would start out in the morning walking up a draw, drop a man off every 30 feet forming a thinning line from 1,200 feet to 1,300 feet long. We thinned as we went up the slopes, sometimes taking two or three days to get to the top." (Van Nice photo.)

In June of 1933, Albert "Al" Thompson of Springfield, South Dakota, who was stationed at Camp Pine Creek, posed near the camp directional sign. (Van Nice photo.)

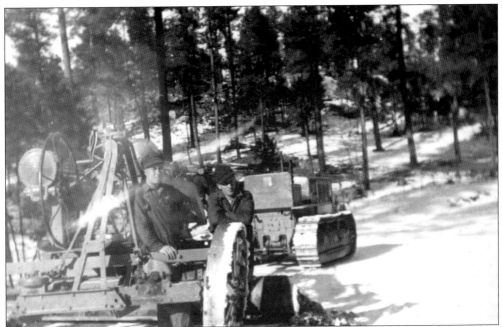

Guy Van Nice and John Dahn became very proficient at running cats and blades while in the CCCs. (Van Nice photo.)

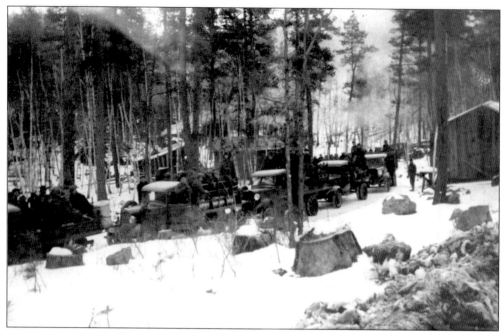

Pine Creek is seen here in the snow. The weather didn't keep the men from riding in the backs of trucks or going to the job site in the woods. (Van Nice photo.)

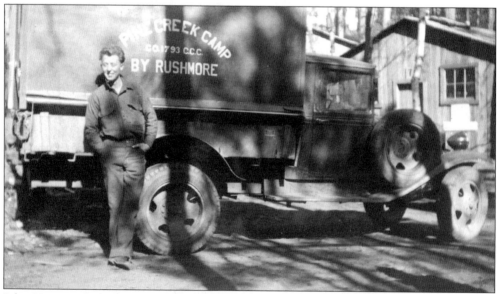

John Hoyme of Marvin, South Dakota drove a truck at Pine Creek in June of 1933. (Van Nice photo.)

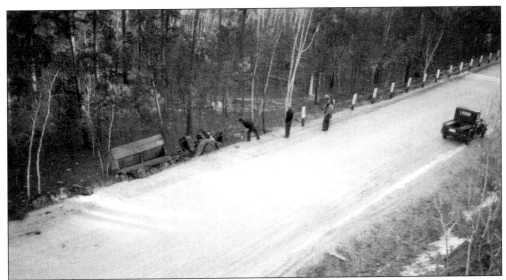

A Pine Creek driver careened off the highway into the guardrail. (Van Nice photo.)

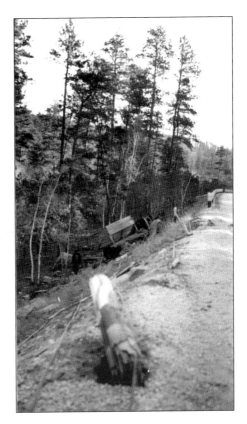

Fortunately, the cable on the top of the guardrail caught the truck and kept it from rolling. Skid marks are visible at the edge of the rail. (Van Nice photo.)

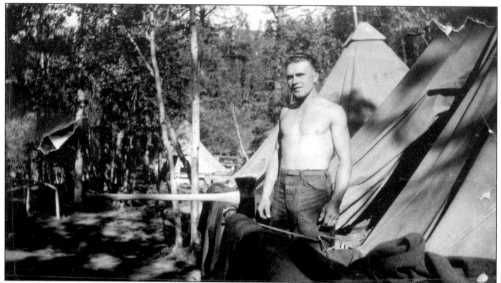

Palmer Hegge was an enrollee on the Victoria Dam Project, a side camp from Pactola. One of his first jobs as part of the thinning crew was sharpening axes. Since the men hadn't used axes before, they dug a lot of dirt as they thinned trees. In time they became more proficient and also learned to sharpen their own axes. In the side camp, away from anywhere, they entertained themselves by having ax throwing contests. (Hegge photo.)

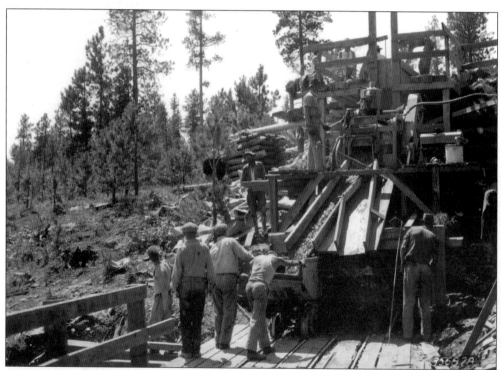

Putting the concrete mixer on the ground-level platform made it easier to get supplies to the mixer and to send the concrete down the chute into the carts for distribution. Palmer Hegge worked on the dam and he now lives near Sundance, Wyoming. (Hegge photo.)

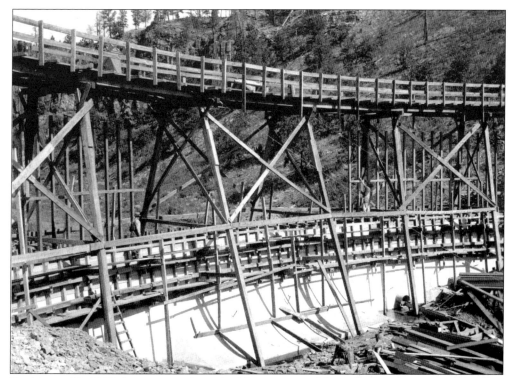

By August 28, 1937 the concrete forms had been removed from the lower section of the dam construction of Victoria. (Hegge photo.)

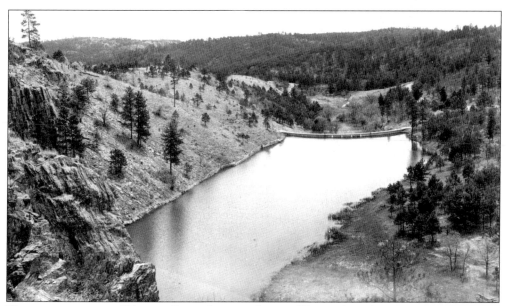

This is an overview of Victoria Dam after completion. (Hegge photo.)

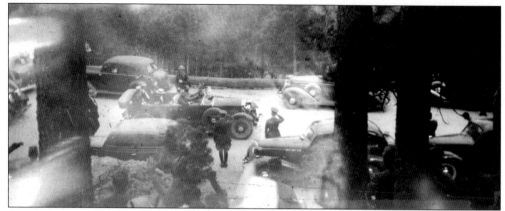

President Franklin D. Roosevelt was at Mt. Rushmore in 1936 to dedicate the latest addition to the sculpture. FDR arrived in this open Lincoln car. (Van Nice photo.)

These three CCC men hung out at Mt. Rushmore in 1935. (Van Nice photo.)

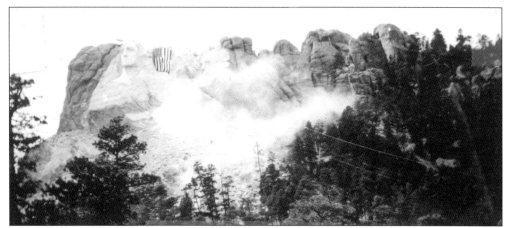

The head of Thomas Jefferson was obscured by the U.S. flag. It was removed after the ceremonial blast. (Van Nice photo.)

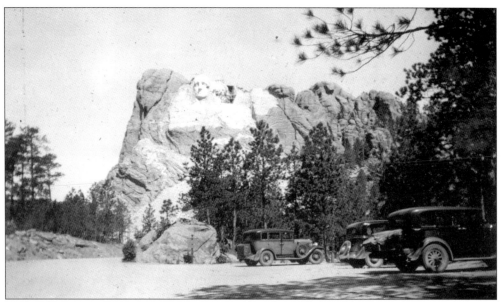

After the flag was removed, guests were greeted by the view of Mt. Rushmore with two faces. (Van Nice photo.

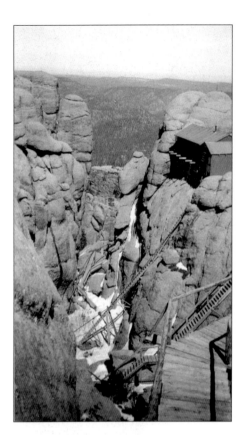

This image shows the wooden steps leading up to the top of Mt. Rushmore and the supply buildings. (Mason photo.)

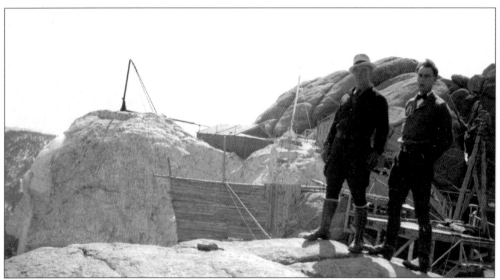

Everitt Clocker (left) and Earl Welton from Rockerville Camp F-10, posed on top of Mt. Rushmore in April of 1935. Washington's head is in the background. (Mason photo.)

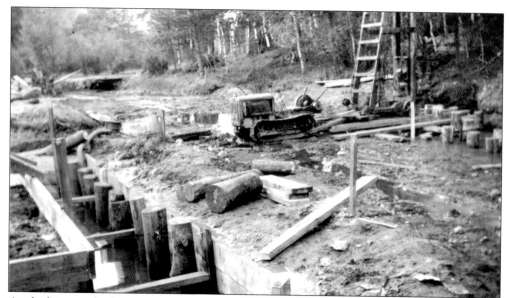

A pile driver and other construction equipment are seen here at Palmer Gulch Bridge near Mt. Rushmore. (Van Nice photo.)

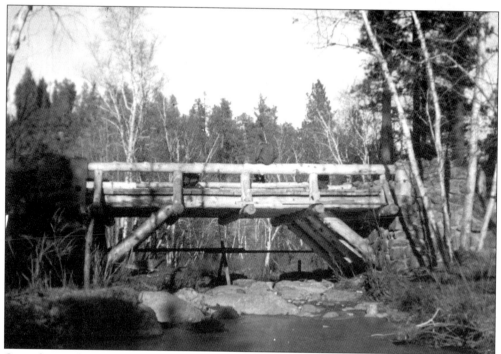

One of many log construction bridges built in Custer State Park during the CCC years. This one was completed in 1935. (Van Nice photo.)

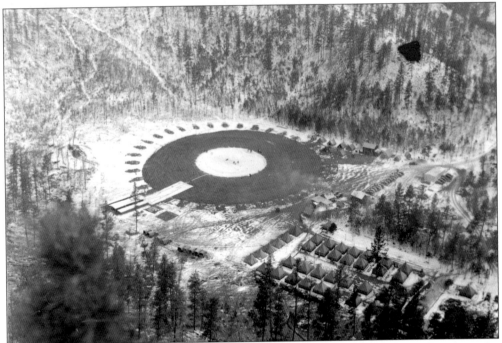

Exciting events that had world-wide implications included the balloon launches from the Strato Bowl south of Rapid City. The photo shows an Army camp that was brought in from Ft. Meade to assist in each Explorer flight. The attempt to get Explorer I, inflated with 3 million cubic feet of hydrogen gas, into the stratosphere failed on July 28, 1934. (Van Nice photo.)

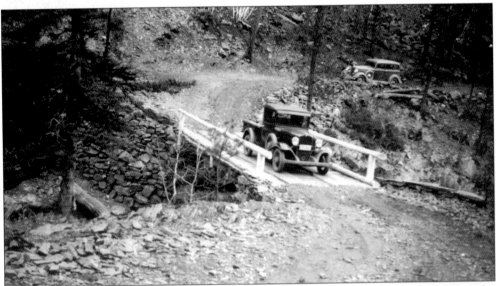

This bridge, built by Company 1794 of the Rockerville Camp, crossed Spring Creek below the Strato Bowl near Deadman Gulch. Other work in the bowl by the CCCs included clearing timber, improving the road leading down into the bowl, and building a guard rail above the bowl as a crowd control measure. Civilian Conservation Corps men from all over the hills, as well as hundreds of other spectators, witnessed the launches. (Mason photo.)

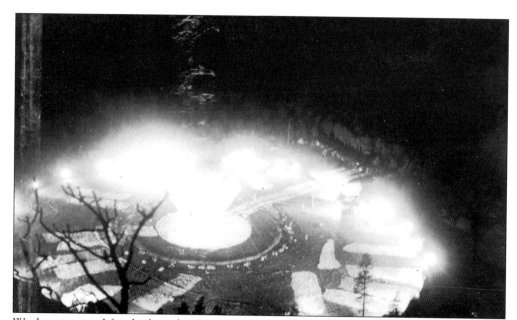

Workers prepared for the launch of Explorer II, which was released on November 10, 1935 at 10:30 p.m. Homestake Mine at Lead brought in the floodlights. Helium was used for this successful launch that took the balloon to a record level float altitude of 72,395 feet, a record that was held for 21 years.

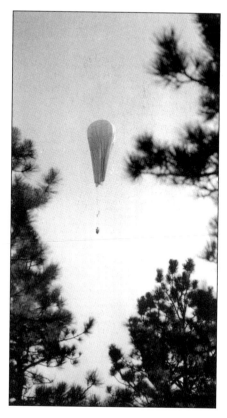

The journey into the stratosphere began from the Strato Bowl in the Black Hills. Explorer II came down in a controlled landing 12 miles south of White Lake, South Dakota after nearly eight hours of flight time. Studies of the instruments contributed to pressurization of aircraft, and the development of an electrically heated flying suit. Two-way long-range radios for aircraft and lightweight metals for aircraft also came about because of these flights.

Sam Lamb was a forestry foreman at Rockerville. (Mason photo.)

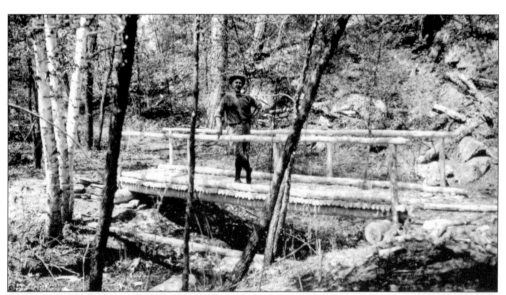

Ralph Smith stood on a log bridge built by the CCCs from Rockerville. The bridge materials were cut from the forest near the site of the bridge, under the supervision of Foreman Smith. (Mason photo.)

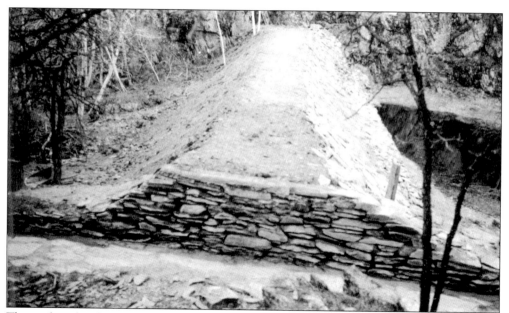

The earthen dam located in the Rockerville Camp Ground was built by enrollees. (Mason photo.)

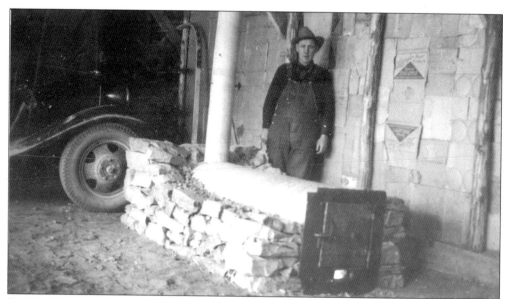

Foreman Ralph Smith created and constructed a garage heater. The firebox consisted of a metal culvert and the rock walls helped radiate the heat. (Mason photo.)

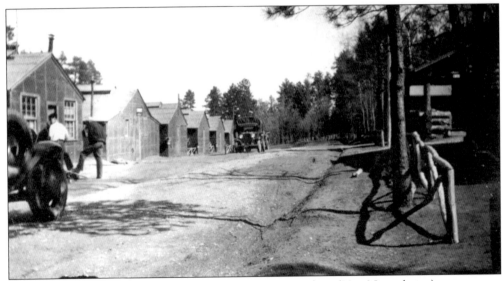

Rockerville Camp was a pleasant place to be in good weather. (Van Nice photo.)

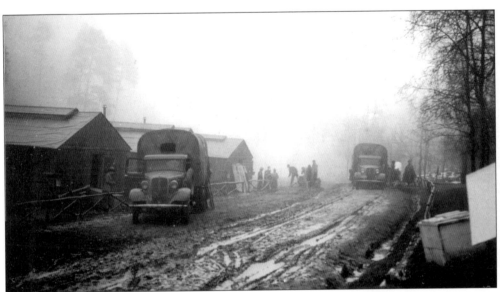

But in rainy weather it became quite a challenge to get around. (Van Nice photo.)

Fritz Heggem was goldbricking or goofing off, by his own admission, in this photo. More likely he was hamming it up for the camera. (Heggem photo.)

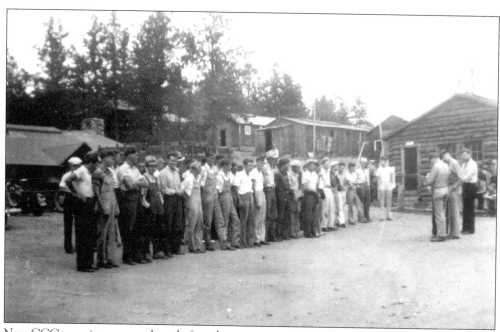

New CCC recruits are seen here before they were given uniforms.

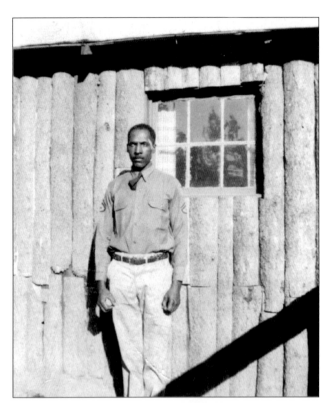

Frank L.B. Johnson was a charter member of Camp Custer. In 1933, he was listed as a woodsman with an Edgemont, South Dakota address, thereafter it changed to Custer. He continued as a woodsman in 1934 and was then both a local experienced man (LEM) as a woodsman and a night watchman in 1935. No report was available for 1936, and by 1937 Frank was listed as an assistant leader, as was Jack Kirchgesler. (Kirchgesler photo.)

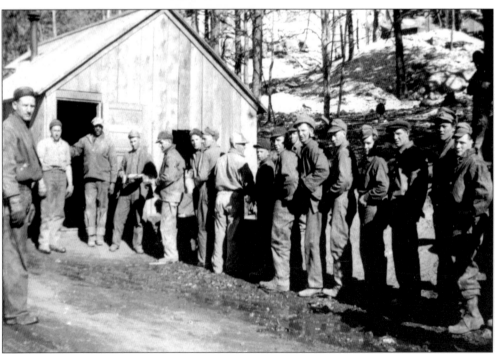

Frank Johnson is the third from left, Pete Heier of Aberdeen, South Dakota is the last man on the right in full view. (Kirchgesler photo.)

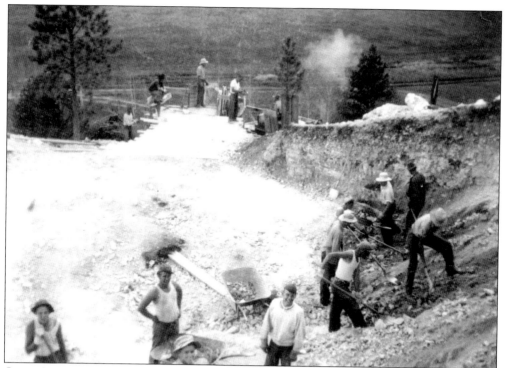

Camp Custer CCC workers quarried rock. (Kirchgesler photo.)

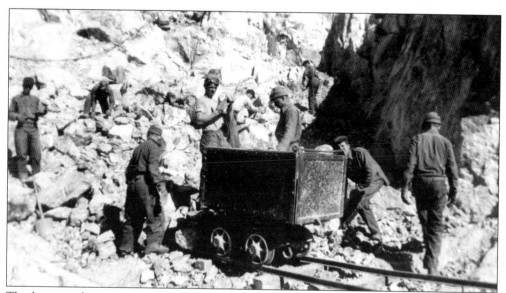

The larger rocks went into the ore cart and were then crushed into gravel and used on area roads. (Kirchgesler photo.)

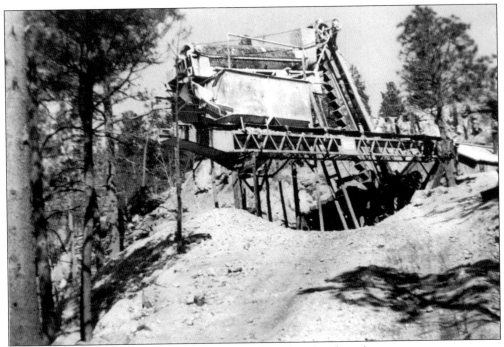

This was the rock crusher used at Camp Custer. (Kirchgesler photo.)

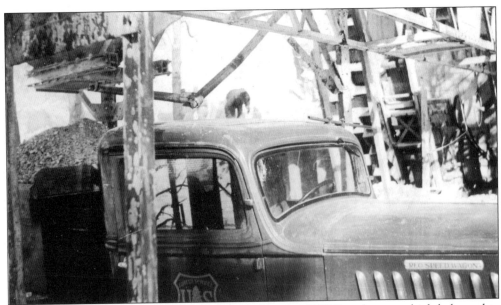

An elevator moved the crushed rock into trucks like this REO Speedwagon which belonged to the U.S. Forest Service. (Kirchgesler photo.)

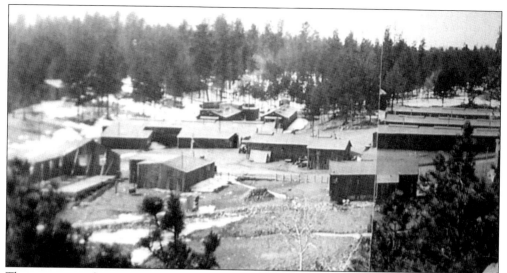

This is a view of Camp Custer F-12, which was built in the valley of a small spring (Vestal Springs). The camp was near the Limestone Ridge, the natural division between the northern and southern Black Hills. Located eight miles northwest of Custer, South Dakota in the Black Hills National Forest, Camp Custer was occupied by Company 1791. (Kirchgesler photo.)

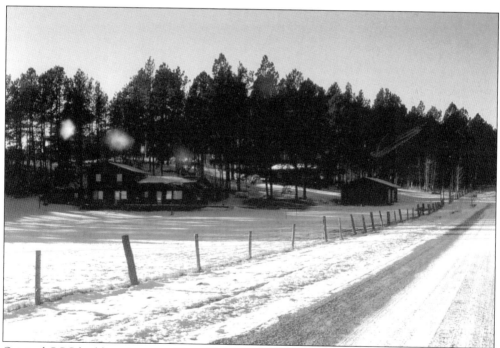

Original CCC buildings in use at Camp Custer in 2004 include two officer's cabins. The building on the left was a one-story CCC cabin onto which a two-story addition was recently added. The building closest to the road was recently built. The focus therefore is on the unchanged officer's cabin which sits back in the trees between the two buildings. (Sanders photo.)

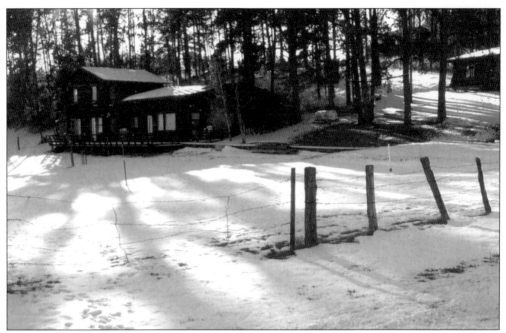

The cabin that has been expanded is now a private residence on the original Camp Custer site. (Sanders photo.)

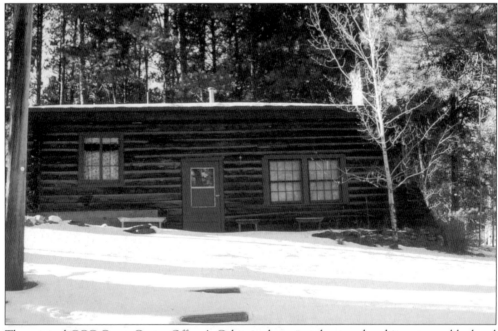

The original CCC Camp Custer Officer's Cabin is also privately owned and is a seasonal bed and breakfast called the Camp Custer Log Cabin. Contact information is at www.custerLcabin.com or telephone the manager, Teresa Pedersen at (605) 673-3683. The Custer, South Dakota Chamber of Commerce also has the B&B listed. (Sanders photo.)

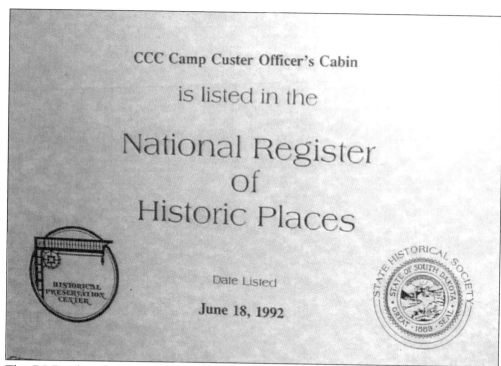

The B&B cabin was named to both the South Dakota State Historical Register and the National Register. The document hangs near the interior cabin door. (Sanders photo.)

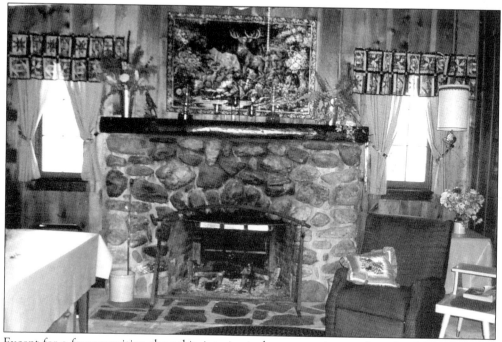

Except for a few amenities, the cabin interior is the same as it was when the CCC closed the camp in 1942. (Sanders photo.)

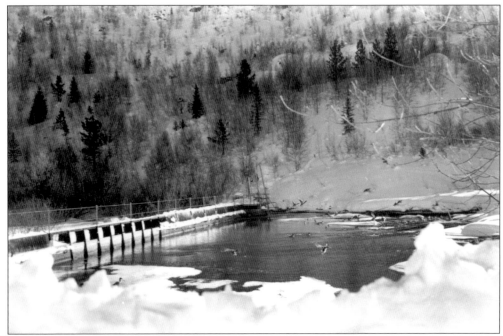

Mallards are seen here on Savoy Reservoir at Savoy F-18, a summer-only tent camp that was occupied over several summers. At one time it was a side camp to Camp F-6 Roubaix. Arnold Blumhardt of Akaska, South Dakota, spent the summers of 1937 and 1938 at Savoy, located in Spearfish Canyon where the camp developed the area of Roughlock Falls. He first served at Camp Roubaix. He now lives in California. (Mason photo.)

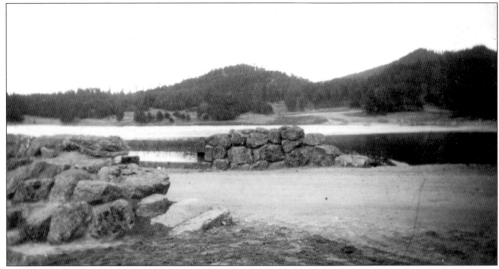

Camp Doran S-2 was five miles east of Custer. Originally it was a tent camp on a spot that is now under Stockade Lake. The permanent camp was established below the dam site on French Creek. Between July 5 and August 1, 1933 the site for the dam was cleared. The dam was first called Doran Lake and later called Stockade Lake. The CCCs developed picnic areas with tables, shelters, and toilets in various spots around the lake. A shoreline drive around the entire lake was also completed. (Van Nice photo.)

Three
FUN, FOOD, AND FORESTRY

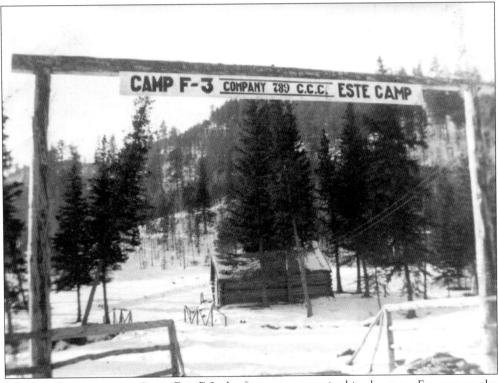

This was the entrance to Camp Este F-3, the first camp organized in the state. Este was on the site of an old logging camp by the same name. That site had a sawmill, which processed trees cut in the first timber sale by the U.S. Forest Service in the country. Also called Nemo, the camp was two miles south and one-half mile west of the town of Nemo. Road 208 crosses Estes Creek and the camp was on the south side of 208. (Raba photo.)

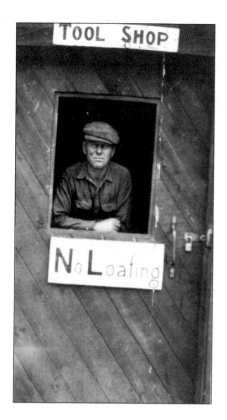

The tool shop at Camp Este was kept in order by this worker. (Raba photo.)

Carrol Jorgensen of Bristol, South Dakota and Earl Price of Tulare, South Dakota were cooks at Camp Este. (Raba photo.)

The Spruce Gulch sign and group is shown here. (Raba photo.)

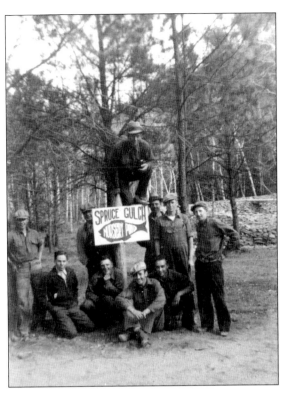

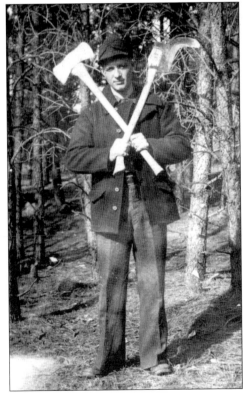

Gabriel Raba is pictured holding his tools of the woodsman trade, a double-bladed ax and a brushhook. (Raba photo.)

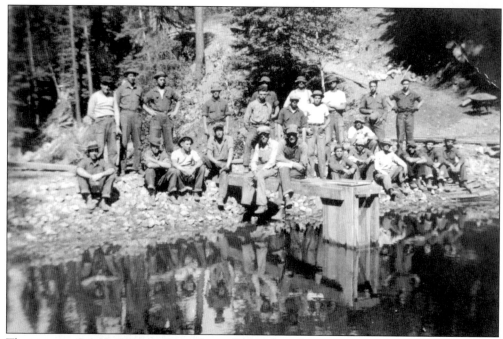

The group at Spruce Gulch is shown here. (Raba photo.)

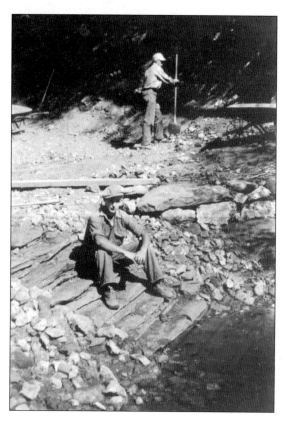

Here, a Spruce Gulch worker takes a
break. (Raba photo.)

An unnamed mascot is pictured with Jack Kirchgesler. (Kirchgesler photo.)

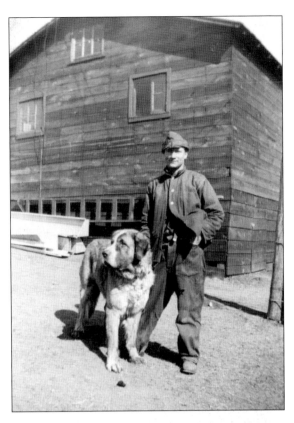

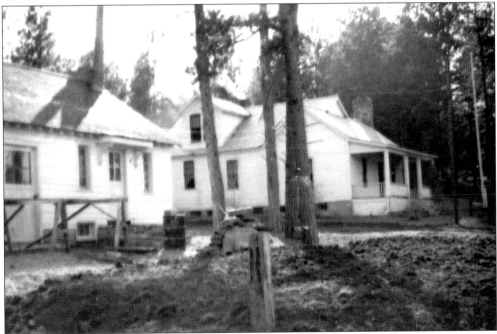

The Nemo Ranger Station was built by Camp Este workers. They also remodeled two houses for rangers. (Mason photo.)

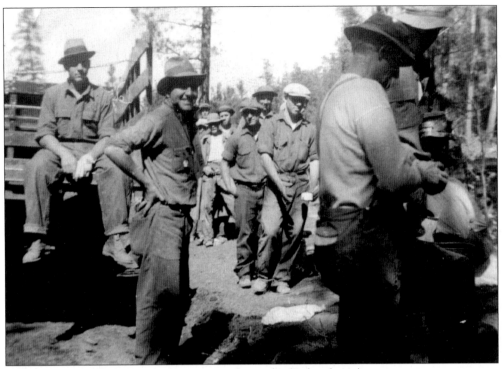

Workers are seen here waiting for repairs to be made. (Raba photo.)

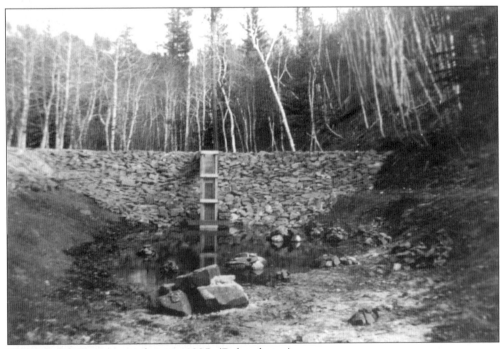

Waite Gulch Dam is seen here in 1935. (Raba photo.)

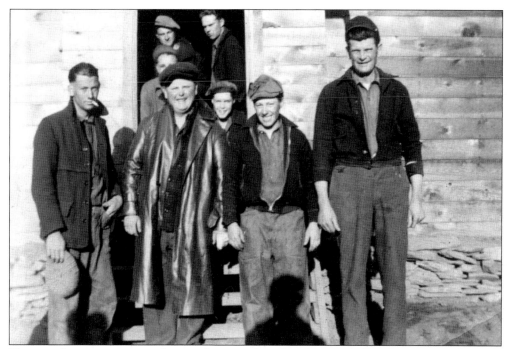

These working men are quite happy after a good meal in the mess hall at Camp Este. The meals sustained the men at Este to complete 9 miles of truck trails, 18 miles of fence, 10 bridges, and 3,000 acres of forest stand improvement, among other projects, within a six month span in 1933. (Raba photo.)

Gabriel Raba of Selby, South Dakota and now of New Underwood, South Dakota, and Robert Huston of Kennebec, South Dakota are pictured practicing their salutes. (Raba photo.)

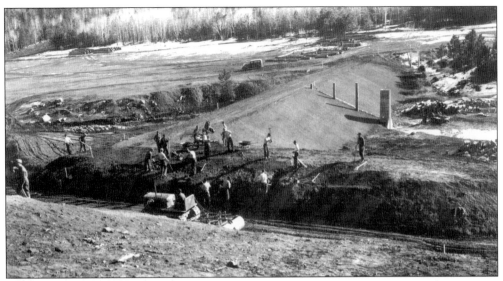

Lake Dalton Dam construction work was done by Camp Este workers in 1933. (U.S. Forest Service photo)

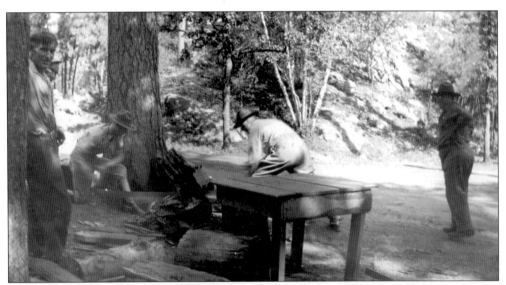

Army officers are shown at Camp Pine Creek. The men on the saw were Army Reserve Engineer 2nd Lt. Edward Caenan of Kansas City, Missouri (left), and Army Reserve Medical Capt. R.W. Allen of Fargo, North Dakota. The other two men are not named. (Van Nice photo.)

Guy Van Nice is seen here on a new Caterpillar, ready for construction work. (Van Nice photo.)

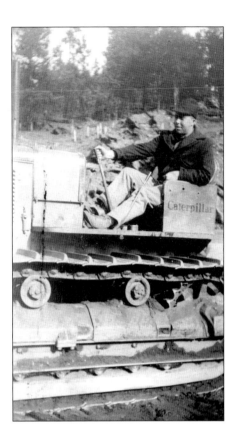

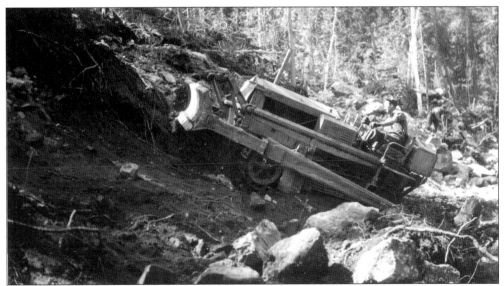

R&T Construction helped Camp Este CCC workers construct a new road for White Gates Truck Trail in October, 1934. The camp further improved the road in 1937. (U.S. Forest Service photo—Kreuger.)

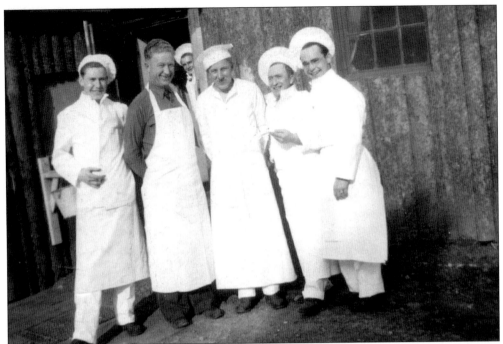

The cooking crew at Horse Creek included local experienced man (LEM) Henry Barone (no hat) who had a small ranch just north of Custer. The other identified man is the shortest man in the group and he was called "Shorty." Age and the marriage restriction (CCC workers were required to be unmarried to be eligible for CCC duty) was lifted for many cooks. (Kirchgesler photo.)

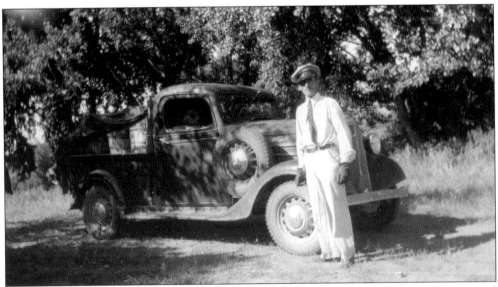

Whenever possible, perishable food was purchased from local vendors. Lyston Wyatt owned and operated a truck garden near Cascade, South Dakota. He always dressed up to go on his produce delivery routes. His 1936 Chevy pickup served him well. (Wyatt photo.)

Lyston Wyatt (left) and his son Russell set out every Friday during the season to take fresh produce to the CCC camps on the southern edge of the Black Hills, Narrows, Mayo, Lightning Creek, Wind Cave, Custer, Lodge, and Doran. (Wyatt photo.)

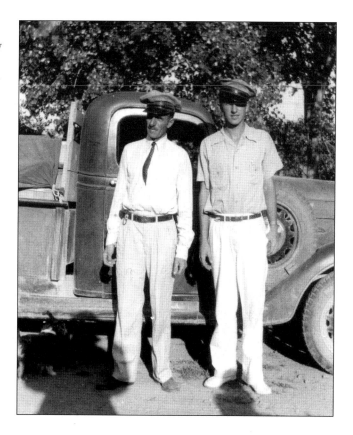

Lyston holds two typical cantaloupes and shows his many bushel baskets full of fruits and vegetables. At Camp Lightning Creek, three meals per day averaged a cost of just under 58 cents per CCC worker. (Wyatt photo.)

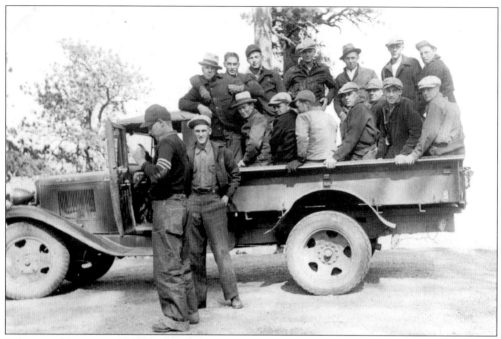

What would OSHA (Occupational Safety and Health Administration) say these days about this method of transporting men to the job site? (Kirchgesler photo.)

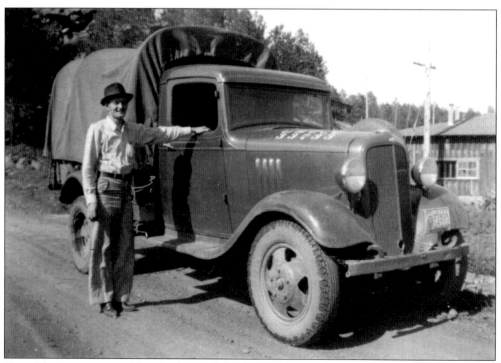

Huey Blessing is pictured beside the truck he drove at Camp Custer. (Kirchgesler photo.)

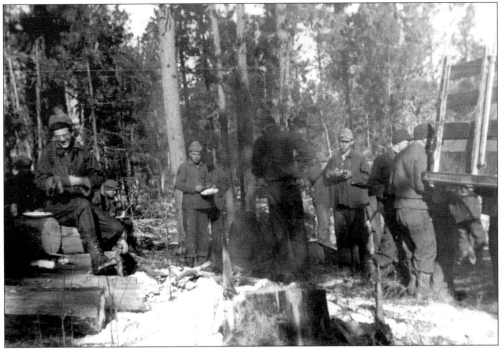

When the work was away from camp, the meals came to the men. Seats were taken where possible and sometimes even in the woods it was standing room only. (Kirchgesler photo.)

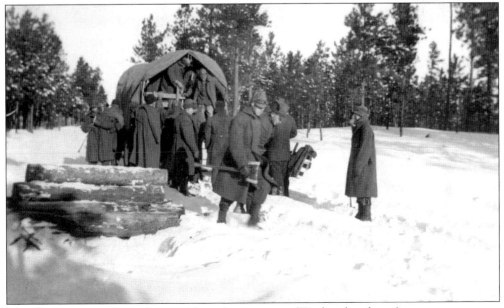

The chow wagon was a welcome sight to hungry men. (Kirchgesler photo.)

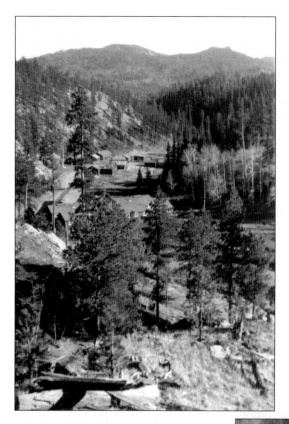

Camp Horse Creek F-2 Company 791 occupied the camp which was a few miles from Pactola, South Dakota. Buildings constructed by the men included a gym large enough for basketball games. Thinning of forests was the primary work project at this camp. (Kirchgesler photo.)

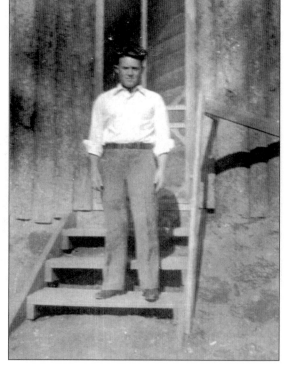

Ed Schipporeit of Rapid City, South Dakota began his CCC enrollment on January 5, 1934 at Camp Rockerville, F-10. Ed served also at Camps F-10 and F-22 at Newcastle, Wyoming. He became an assistant leader as first cook before being honorably discharged from Camp Lightning Creek, F-14 on June 3, 1936. (Schipporeit photo.)

CCCs thinned this stand of overcrowded Ponderosa Pine to stimulate growth of the trees that were left. Tree stands shorter than $4^1/_2$ feet tall with a diameter less than 6 inches were thinned. Diseased and dead trees were also taken out. Approximately 204,600 acres of trees in the Black Hills were thinned between the years of 1933 and 1937. In addition to creating healthier forests, there was the practical side of using the thinned trees. (Mason photo.)

After thinning, the remaining trees had a better chance of being healthy and reaching a mature size. The thinned trees were removed once an area had been completed. The larger ones were made into posts and poles for use in the CCC projects. Firewood was made out of the balance, much of that was shipped by train to other areas of the state where it was needed. The State Relief Committee doled out the firewood. (Mason photo.)

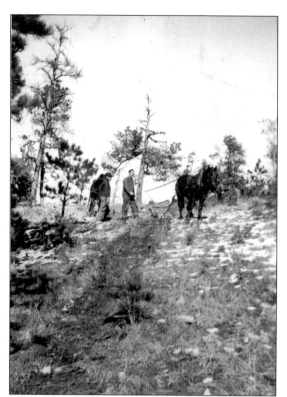

Jewell Cave had a side camp, established in 1935, from Wind Cave. The camp had adequate quarters for 30 men, which was just the number of workers stationed there in the winter of 1937. The CCC workers built trails, transplanted trees, and laid water and underground telephone lines. They built fireplaces and completed a modern camp ground, in addition to constructing a new elevator building. (Dale Sawyer photo.)

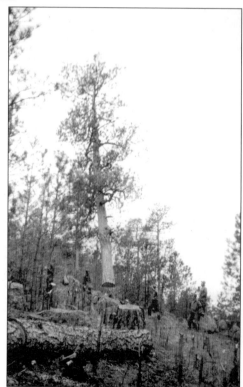

Guy Van Nice got this shot with his small box camera. (Van Nice photo.)

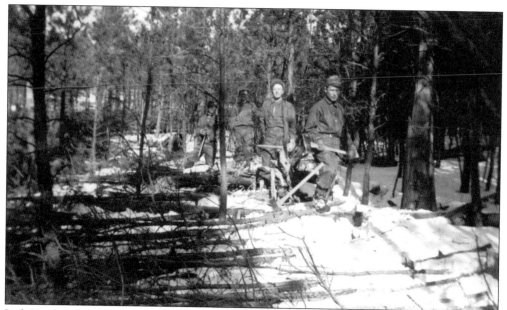

Jack Kirchgesler's first CCC job was thinning timber, and along with that came the skidding. (Kirchgesler photo.)

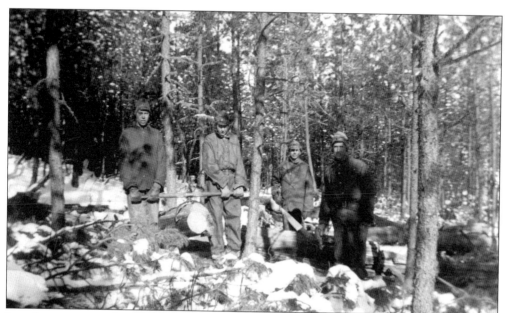

It took cooperation for men to manually move the cut-down trees. A tong-like hook dug into each side of the log and as long as each man held up his side of the handle, the log was able to be moved. (Kirchgesler photo.)

Tom Sawyer, park ranger from Wind Cave, was spraying for pine beetles. In 1935 alone, 8,475 acres of trees were treated for the beetles. (Dale Sawyer photo.)

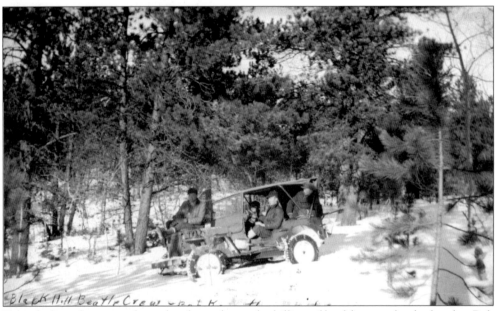

To curb the infestation of pine beetles and stop the killing of healthy trees by the beetles, Bob Korthaus ran one of the spray rigs. (Dale Sawyer photo.)

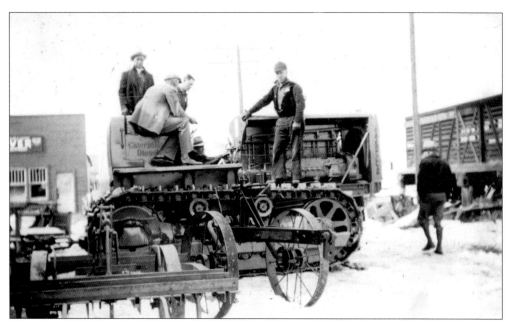

On March 9, 1935 Guy Van Nice and others in the CCCs went to Rapid City for a school on how to run the 75 Diesel Caterpillar. (Van Nice photo.)

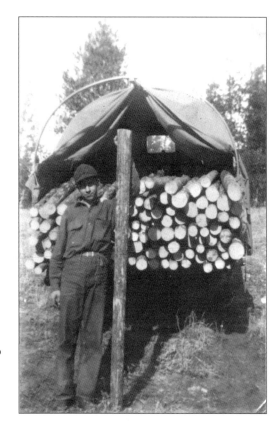

Jack Kirchgesler was on a post-peeling crew, using a draw knife to peel the posts. He broke the record by peeling 31 posts in one day. To accomplish this feat, he had to finish the last post after the truck to take him back to camp pulled out. He set the record then ran to catch the truck. (Kirchgesler photo.)

Honorable Discharge
from the
Civilian Conservation Corps

TO ALL WHOM IT MAY CONCERN:

This is to Certify That* OLIVER J. TORVE, VCC7-39188

a member of the CIVILIAN CONSERVATION CORPS, who was enrolled

November 23, 1933 _____ at Camp F-17, Tilford, South Dakota ____, is hereby
(Date)

HONORABLY DISCHARGED therefrom, by reason of** Convenience of the

Government, account of termination of the CCC.

Said Oliver J. Torve was born in Yankton

in the State of South Dakota When enrolled he was Forty-four years

of age and by occupation a Laborer He had Blue eyes,

Brown hair, Medium complexion, and was Five feet

nine inches in height. His color was white

Company 2759 V-CCC,
Given under my hand at Camp F-3, Roubaix, S.D., this twenty-eighth day

of July , one thousand nine hundred and forty-two

F.O., U.S. Army, Omaha, Nebr.

AUG 4 1942
_____19_____

Paid in full on F/S, Pay $_____ _Clinton F. Palmer_ COMPANY COMMANDER
(Name) (Title)
Coll. 8.38 CLINTON F. PALMER
* Insert name, as "John J. Doe." Allot. 19.62
** Give reason for discharge.
C. C. C. Form No. 2 F. PEARSON, COL., F.D.
April 5, 1937

by

100

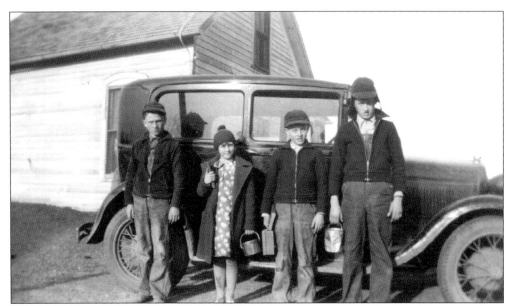

The CCCs had separate camps for World War I veterans, and Oliver Torve was a vet. For nine years he worked away from home in the CCCs, returning to his family only one time per year. He rode the train to Marion, South Dakota then caught a ride to his farm. Oliver and Maggie's children, pictured from left to right, were: Lemoine, Elizabeth, Kermit, and Vilas. In 1942, Oliver received a veteran's bonus with which he bought the 1928 Model A. (Torve photo.)

SAFETY FIRST IS OUR RULE
SOMEONE ELSE MAYBE A FOOL

As in any occupation, safety reminders were necessary facts of life. (Kirchgesler photo.)

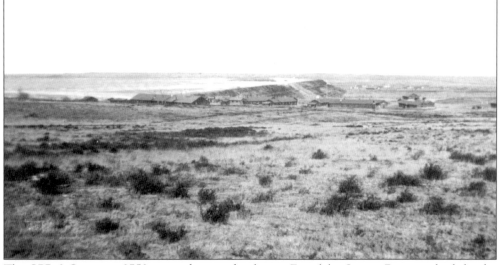

The CBR-2 Company 2750 is seen here at the dam at Fruitdale. Orman Dam was built by the Bureau of Reclamation beginning in 1904. The CCCs worked on improving and repairing the dam, graveling roads, poisoning grasshoppers, and constructing a water storage system made of concrete. They cleaned vegetation from canals, helped replace seven culverts on the main canal and constructed stock dams, among other projects. (Kirchgesler photo.)

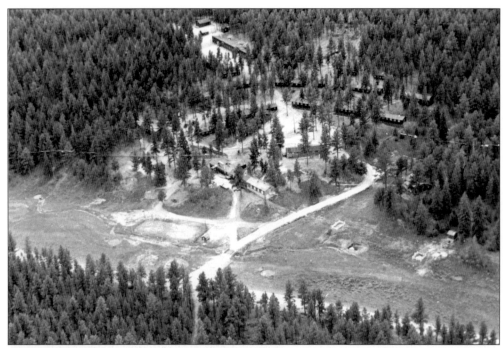

Roubaix, Camp F-6 was 15 miles south of Deadwood on the west side of Highway 385. In 1940, the men of Roubaix planted trees. One hundred men planted 500 trees each, per day, for at least 30 days. Each man carried his seedlings in a pouch and every six feet—or two large steps—he would make a slice into the ground with a certain type of shovel, slip the seedling into the open space, and step once on the spot next to the tree to press the ground back together. (Patterson photo.)

102

Four
LOG AND STONE
LEGACIES

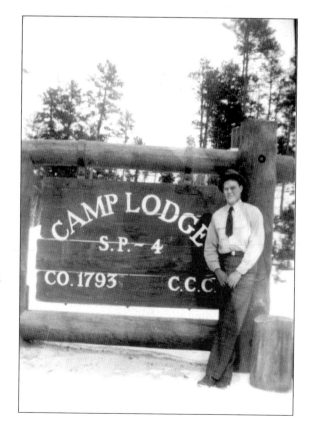

Dave Davis, a CCC enrollee from Baker, Arkansas, is seen here at the entrance to what was then Camp Lodge and is now known as the Black Hills Playhouse. Dr. Warren M. Lee had a dream of bringing summer theater to the Black Hills and over time Camp Lodge became the realization of that dream. The book by Dorothy Ross Delicate, *One Man's Dream*, tells the story in wonderful detail of the playhouse and how it came about. (Heggem photo.)

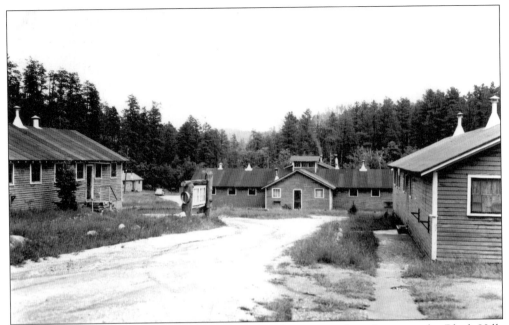

Twelve buildings that were used by CCC personnel remain and are in use at the Black Hills Playhouse. On the left was a PX, or store, for the CCCs, which is currently a ticket office. The building on the right was the Lee residence and rehearsal hall and is now the snack bar. (Black Hills Playhouse photo.)

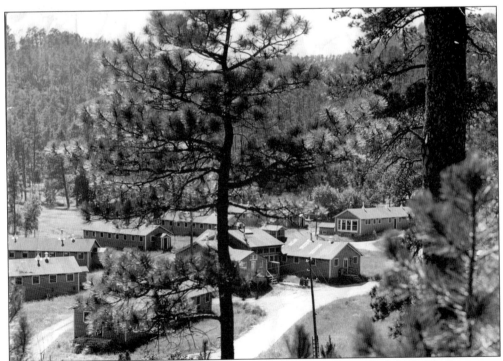

A 1946 aerial view of Camp Lodge shows how it looked when the Black Hills Playhouse was first started. (Black Hills Playhouse photo.)

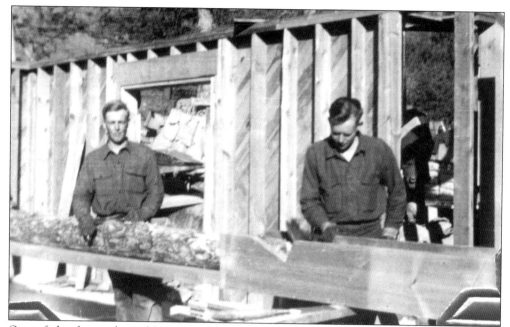

One of the first orders of business at Camp Lodge was building quarters. Fritz Heggem is pictured on the left. (Heggem photo.)

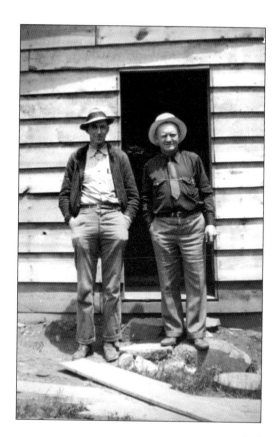

Ralph Brigham of Vale, South Dakota, left, and Monte Nystrom of Custer were supervisors at Camp Lodge. (Heggem photo.)

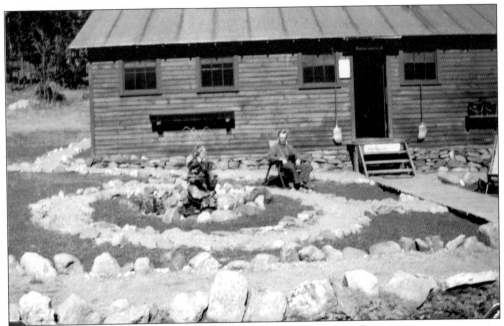

The Camp Lodge Infirmary was nicely landscaped. (Heggem photo.)

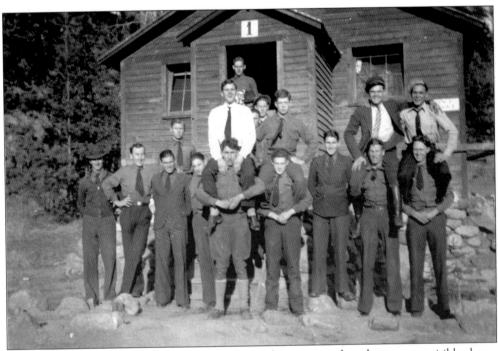

Barracks 1 at Camp Lodge and the four piggy-back riders amongst the other men are visible above.

Many signs like this one erected in 1935 were CCC projects. (Van Nice photo.)

Pictured above is a pigtail or spiral bridge built by the CCCs on Iron Mountain Road in Custer State Park. (Van Nice photo.)

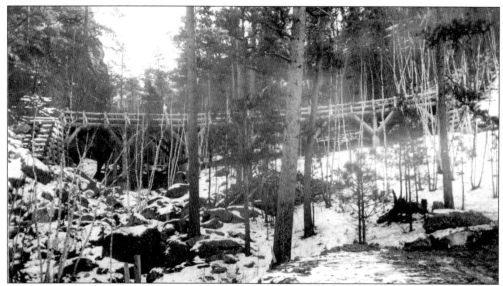

This is another CCC constructed bridge on Iron Mountain Road. Think of how it was made. The trees were felled, hauled by hand, peeled, and formed into this structure that still is in use today. (Van Nice photo.)

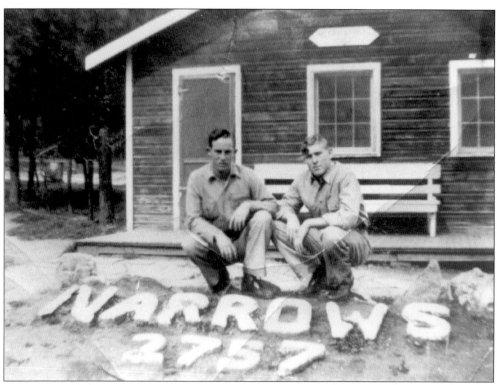

Camp Narrows, also called Robber's Roost, only had one company, 2757, during the years from 1934 to its closing in 1941. Narrows developed horse trails walking trails, built park fences, buffalo watering troughs, and numerous stone and timber bridges. (Holden photo.)

Camp Narrows, shown here, was located near the Blue Bell Resort one of the projects of Camp Narrows. (Van Nice photo.)

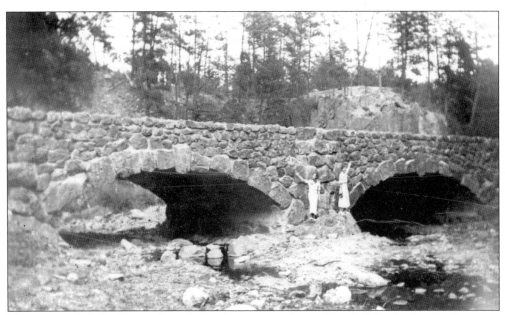

This is one of the bridges on French Creek constructed near Blue Bell by the CCCs. Company 2757 also built water supply lines at the State Game Lodge and Legion Lake. (Van Nice photo.)

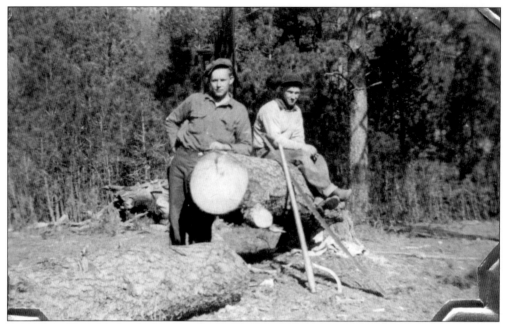

Many logs like this were cut everyday by man-power-driven saws. Frtiz Heggem, left, and Kenneth Simonson were taking a breather. (Heggem photo.)

Shaffer used his team and sled to move rocks or poles for building. (Heggem photo.)

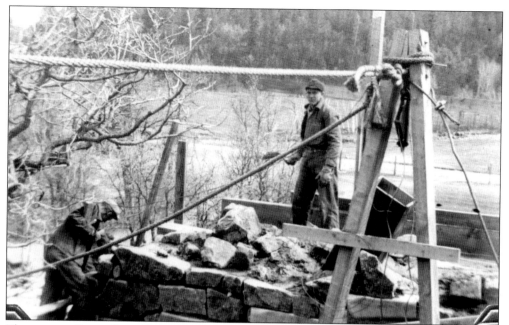

The current Custer State Park Museum got its start like this, one stone at a time. The mason skills acquired by these men served them well through the years. (Heggem photo.)

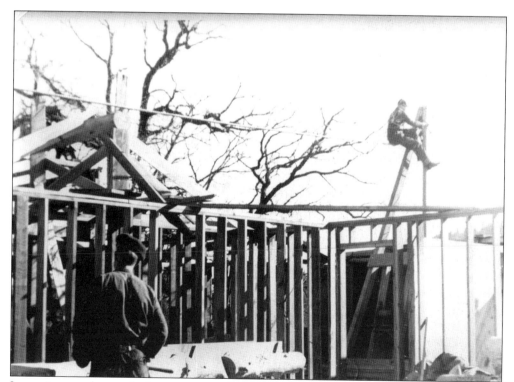

Ingenuity was the word when it came to building the museum. Fritz Heggem had his back to the camera. (Heggem photo.)

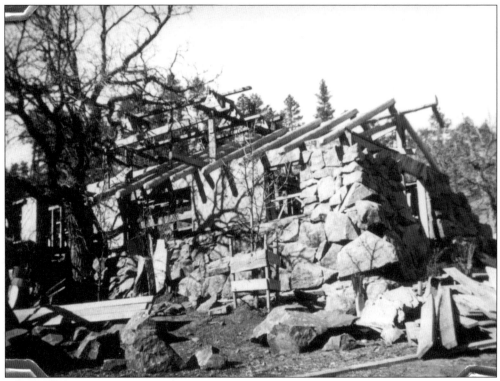

The wooden structure of the museum was finished off by the stone. (Heggem photo.)

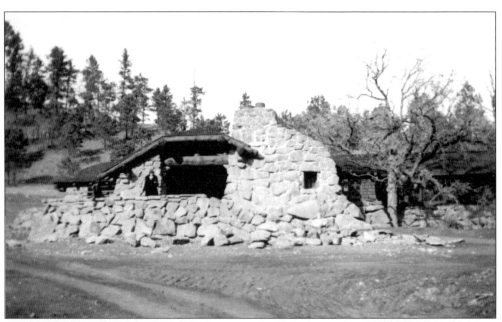

The Custer State Park Museum was completed by Company 1793 in 1934. After the company was later transferred to Camp Lodge, they had the privilege of helping create the exhibits inside the museum. (Van Nice photo.)

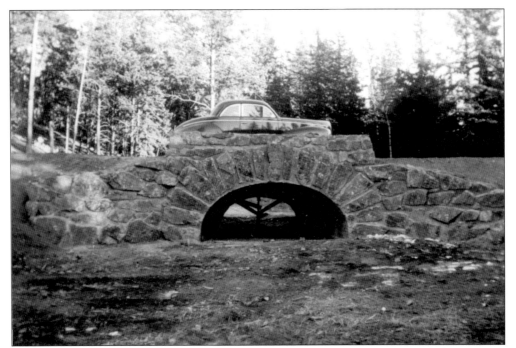

Guy Van Nice captioned this photo, "I built this bridge in 1940." (Van Nice photo.)

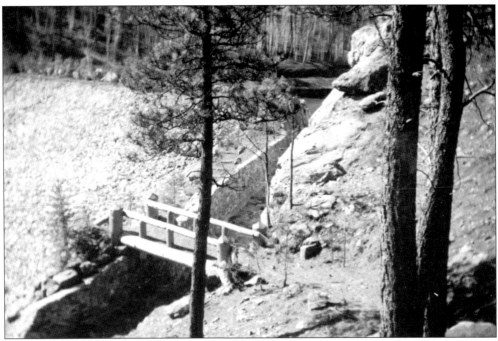

Pine Creek Camp, Company 1793 built this footbridge in Custer State Park. (Van Nice photo.)

Lawrence Melvin of Rapid City, South Dakota, left, and M.A. "Curly" Garland, also of Rapid City, were supervisors on this rock construction. (Van Nice photo.)

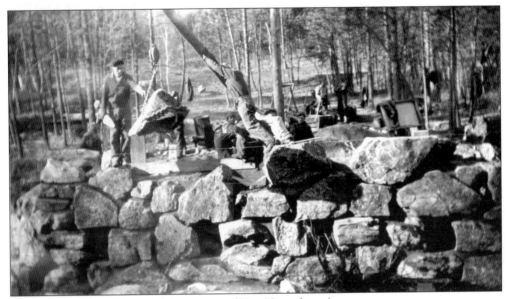

This picnic shelter was a work in progress. (Van Nice photo.)

The entrance to Grizzly Bear Campground near Keystone is seen here in 1935. (Van Nice photo.)

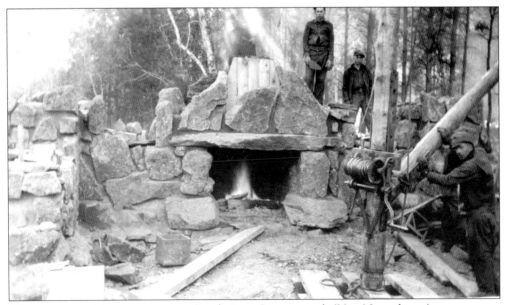

Witt was the chief stone mason at Grizzly Bear Campground. (Van Nice photo.)

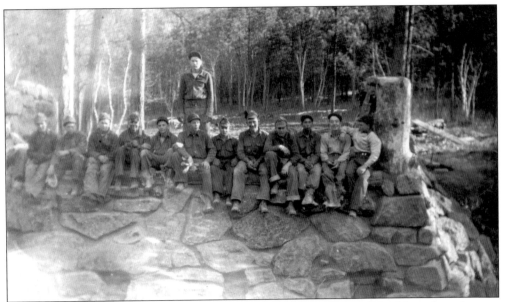

Witt and crew are seen here taking a break from stone construction. (Van Nice photo.)

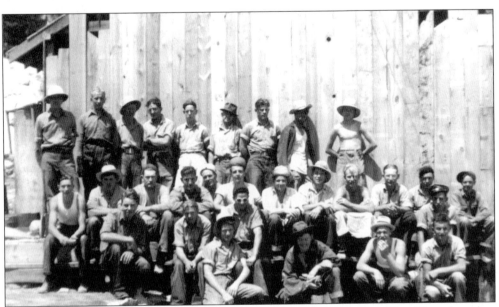

Part of the crew on the Iron Mountain projects can be seen in this shot. (Van Nice photo.)

The Harney Peak Lookout Tower was built by Camp F-23, Doran to replace the old wooden structure. Over 7,500 rocks had to be hauled up the mountain on specially built horse-drawn sleds. Everything necessary was sledded up or carried by the men as they climbed to the job site. The U.S. Forest Service recently did repairs at the tower in the hope that the shelter will be respectfully used. (Mason photo.)

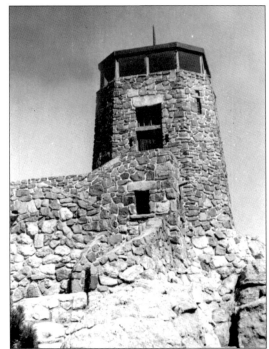

Milton and Marian Schleve might be called Mr. and Mrs. CCC of the Black Hills because they hosted many area CCC reunions. Milt was enrolled in October of 1935 through March, 1936, first working on the dam spillway at Pine Creek. He had the good fortune to witness Explorer II's liftoff from the Strato Bowl. After a brief transfer to Camp Narrows, he was sent back to Pine Creek, and later to Lodge. (Schleve photo.)

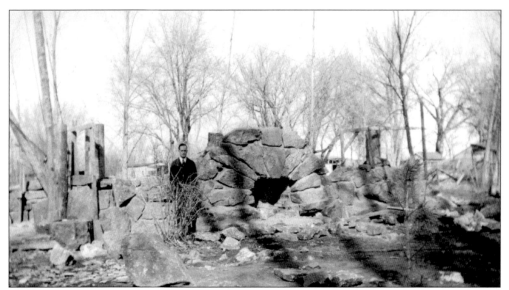

Waldo Winter of Davenport, Iowa was the National Park Service Chief Engineer on the Canyon Lake Municipal Park project in Rapid City. Guy Van Nice, then of Rapid City, South Dakota spent February and March of 1936 working at this side camp as the junior foreman. (Van Nice photo.)

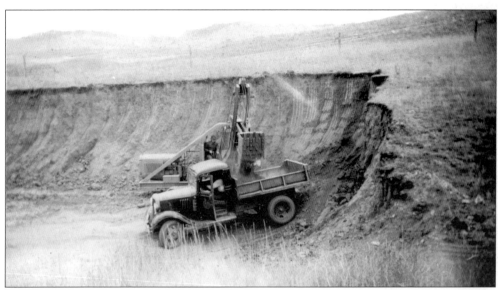

Camp Narrows had a side camp with 50 men at the Canyon Lake project. They built new roads and a new beach. The truck moved dirt for the municipal park at Canyon Lake. The men constructed ponds, guard rails, and a nice entry area. (Van Nice photo.)

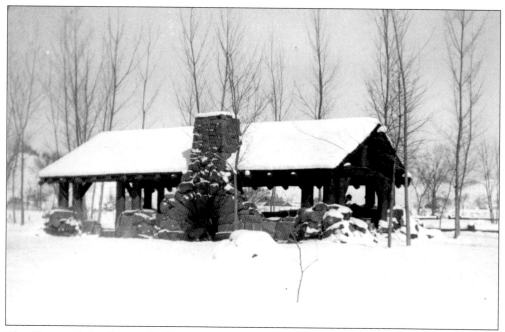

The Canyon Lake Picnic Shelter was part of the project, along with a fireplace and picnic tables. (Van Nice photo.)

Another project of the side camp was the construction of the fish hatchery ponds in Rapid City. The work done on the hatchery and the municipal park was destroyed in the disastrous 1972 Rapid City flood. (Van Nice photo.)

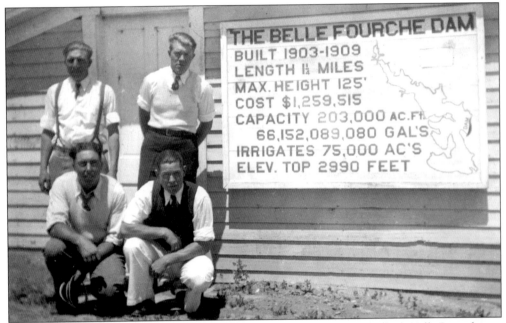

On July 4, 1934 these Brown County, South Dakota men took in the Black Hills Roundup in Belle Fourche, South Dakota and voyaged to nearby Belle Fourche Dam, also called Orman Dam. Pictured, from left to right, in front, are: Guy Van Nice of Pierre, and Bill Emery of Barnard; in back, Herb Pautsch of Westport, and Paul Emme of Dallas.(Van Nice photo.)

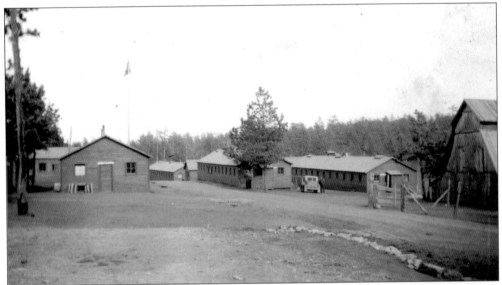

Tigerville, Camp F-15 was located 12 miles west of Hill City, South Dakota. It was one of the few camps that was built before it was occupied. It had running water and electricity installed and ready to go when the men moved in. (Van Nice photo.)

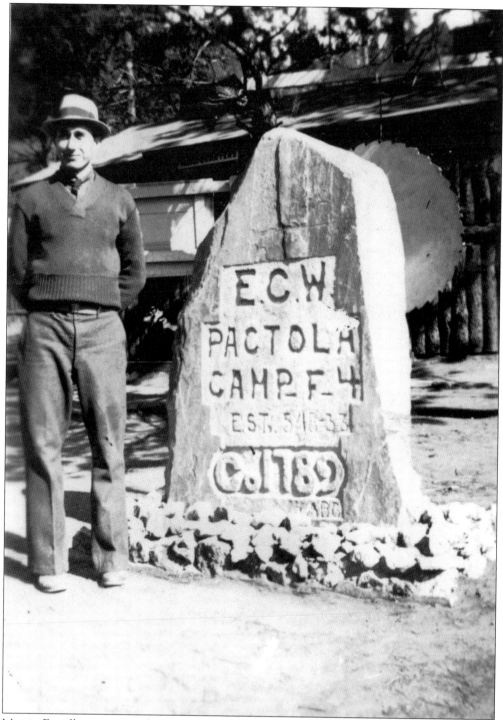

Martin Farrell was stationed at the Pactola Camp, F-4 in Company 1789. The E.C.W. on the stone was for Emergency Conservation Work, the official name of the CCCs for the first few years. Since everyone, even President Roosevelt called it the Civilian Conservation Corps anyway, the name was changed. (Farrell photo.)

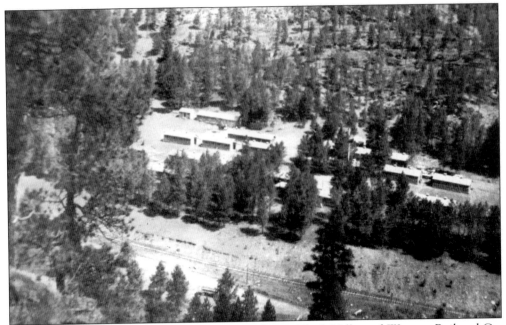

The overview of Pactola Camp, shows the Rapid City, Black Hills, and Western Railroad Co. railroad at camp's edge. (Farrell photo.)

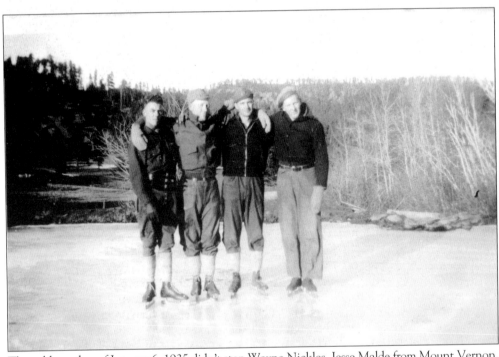

The cold weather of January 6, 1935 didn't stop Wayne Nickles, Jesse Malde from Mount Vernon, South Dakota, Ray Roth, and Calvin Smith from enjoying the ice skating. (Farrell photo.)

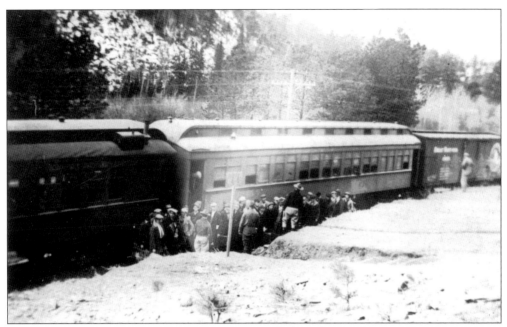

New recruits arrived on the train at Pactola. (Farrell photo.)

These men of Camp Pactola, Barracks No. 11, were all from South Dakota. Pictured, from left to right, front row: Rollo Bryan of Hetland, Martin Farrell of Plankinton, Stub Walter of Corsica; second row: Walter Weghaupt of Mount Vernon, Emmet Stergel of Milbank, Joe Bensely of Iroquois, Ermest Knetachmomes of Mt. Vernon; third row: Dale Rothwell of Wessington; back row: Oliver Reiser of Olivet, Dick Formaneck of Roswell, Harry Rath of Menno, and Clarence Forman of Forestburg. (Farrell photo.)

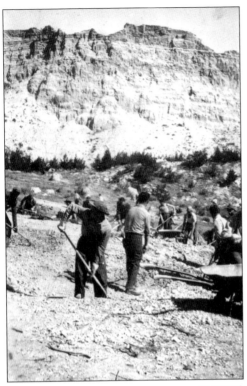

On November 1, 1939 Camp Wind Cave, Company 2754 transferred to Camp Interior, NP-3, in the Badlands 140 miles from Wind Cave. Thirty trucks made up the convoy that moved the men and their equipment. Shovel detail began soon after arrival. (Dale Sawyer photo.)

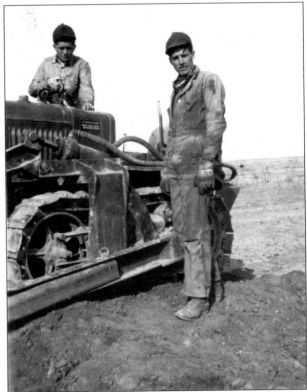

Camp Interior was located three-quarters of a mile south of Cedar Pass. Much of the work in the Badlands was on road improvement and construction. A second one, Camp Badlands, NP-2, was near the Pinnacle Entrance. (Dale Sawyer photo.)

Part of the Badlands crew was taking a photo break on the rock crusher at Cedar Pass. Rocks were crushed for gravel and spread to get the road in good enough condition so the trucks could use it. Over 100 cubic yards of gravel per mile were used on the project. (Dale Sawyer photo.)

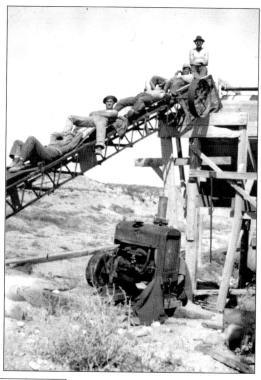

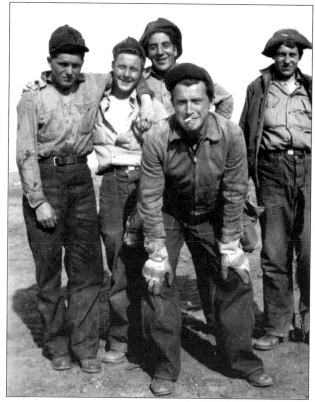

The boys from the Badlands had a good time even during duty hours. One of the projects undertaken was the construction of a water system at the headquarters at Cedar Pass. (Dale Sawyer photo.)

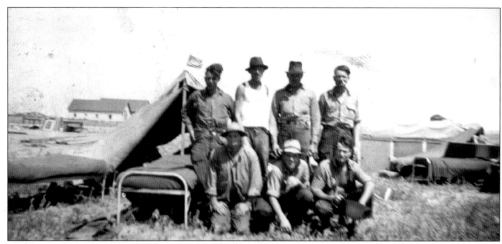

Summer accommodations in the Badlands included just sleeping under the stars with the jackrabbits and rattlesnakes. At least the men had cots. (Dale Sawyer photo.)

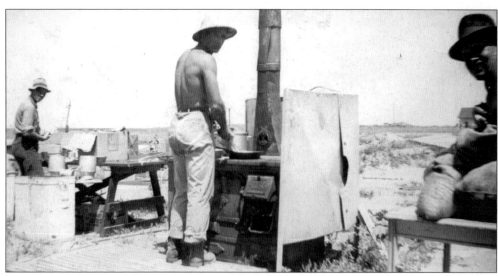

The summer kitchen in the Badlands was primitive but practical. (Dale Sawyer photo.)

Tom Sawyer is pictured here at Smith's Spur. (Dale Sawyer photo.)

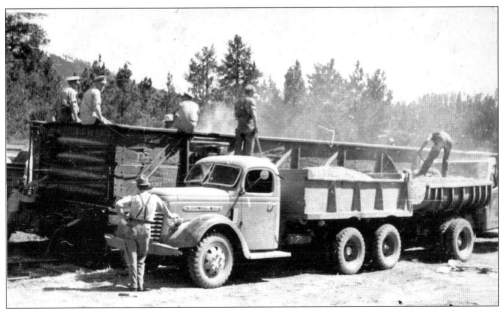

Smith's Spur, the railhead for Camp Tigerville was nine miles northwest of Hill City. Tom Sawyer is leaning on the truck, supervising. (Dale Sawyer photo.)

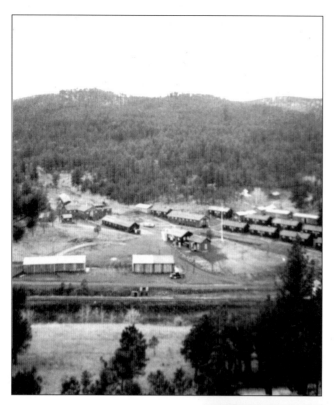

Camp Mystic, F-1 was located about four miles south of Mystic. Like other camps in the forest, tree thinning, building roads, and fighting forest fires were the primary duties. In 1937, Company 1790 received an award from the 7th Corps for going 100 days without a lost-time accident. It was a record-setting achievement in the 7th Corps.

Carl Sanders worked as a forestry foreman in the CCCs at Camp Calcite, F-17, Company 1784-V beginning on September 5, 1934 and at Camp Mystic, F-1, Company 2763 in 1936. He and his wife Jessie ran the Triangle I Guest Ranch near Hisega, South Dakota for many years. In the photo Carl was 93 years old, sipping his Seagrams and sugar and smoking filter-less Camel cigarettes.